RENZO PIANO

SPIRIT OF NATURE
Wood Architecture Award 2000

BUILDING INFORMATION LTD

PUBLISHER	Wood in Culture Association
	Salomonkatu 17 B
	FIN-00100 Helsinki
	tel. +358 9 6850 8841
	fax +358 9 6850 8820
	woodinculture@smy.fi
	www.spiritofnature.net
PUBLISHING COMPANY	Building Information Ltd
LAYOUT	Anders Adlercreutz
EDITOR	Kristiina Lehtimäki
TRANSLATION (HÄRMÄLÄ AND MAHLAMÄKI)	Harry Charrington
ENGLISH EDITING	Harry Charrington
TEXTS IN THE PROJECTS	Aymeric / Renzo Piano Building Workshop
PHOTOGRAPHS	Renzo Piano Building Workshop
TYPEFACE	Rotis Sans Serif
REPRODUCTION	Karisto Oy, Hämeenlinna 2000
PAPER	Galerie Art Silk 170 GSM, Metsä-Serla Oyj
	Äänekoski Art Paper Mill
ISBN	951-682-606-7
PRINT	Karisto Oy, Hämeenlinna 2000
©	Wood in Culture Association, Renzo Piano
	Building Workshop and Building Information Ltd
	(Rakennustieto Oy), www.rakennustieto.fi

Forest and Architecture

FINNISH FORESTS
—
GROWING IDEAS

Architecture provides a perfect medium for presenting the unique qualities of wood. Wood is a light, mouldable and strong material. Its insulation values are high and as a surface material it is lively and natural. It is a sustainable material and the only raw material in the building trade which has environmental certification.

Finnish forest owners, the forest industry and the Forest and Park Service jointly founded the Finnish Forest Foundation to reinforce the positive image of wood as well as to promote its use. It had become apparent that wood as a material needed spokepersons, visionaries and makers. All of which ties in with the innovation, product development, research and dissemination of the field.

The Finnish Forest Foundation has been involved in establishing the Spirit of Nature Wood Architecture Award. The Award is an excellent opportunity to highlight architecture that can create sustainable, ethical and ecological habitats for the people of this new century.

Esa Härmälä
The Chairman of the Finnish Forest Foundation

Foreword

The Wood in Culture Association was set up to promote and foster the use and image of timber. Subsequent to this the Association established the international *Spirit of Nature Wood Architecture Award*.

The influence of wood, 'breathing the presence of nature', is evident in many parts of our culture. Timber, owing to its great versatility as material, has always been a stimulus to the imagination. Skilfully utilised in the past, it retains just as much relevance in the present. Today's architects appear equally interested in using high-tech and traditional materials, such as timber, in modern construction and the Wood in Culture Association's aim is not only to foster tradition but to bring out and encourage new, young talent.

The Spirit of Nature Wood Architecture Award was established in 1999. The Award stands for architectural excellence and is given to a person or a group of persons whose work exemplifies a progressive and creative use of timber. The Association wishes to use the Award to support and highlight internationally forms of architecture in which timber occupies the central position.

The Spirit of Nature Wood Architecture Award will be given every second year. The recipient of this First Award in 2000 is the world famous Italian architect Renzo Piano. We thank him and his office for the excellent pictures and texts that made the publication of this book possible.

The Award ceremony was held on September 7th 2000 in a building which may be described as the flagship of Finnish timber construction in the new Millennium – the new Sibelius Hall Congress and Concert Centre in Lahti. The event was televised by the Finnish television network MTV3 and broadcast in many other countries by the European Broadcasting Union. At the ceremony, the Sinfonia Lahti was conducted by Osmo Vänskä and the soloist was the violinist Leonidas Kavakos. The Award of EUR 50,000 was made possible through the support of the Finnish Forest Foundation.

The Wood in Culture Association wishes to proffer its warm thanks to the Jury of the first Spirit of Nature Architecture Award for their professional judgement which resulted in such an excellent choice of recipient. The members of the Jury were architects from three countries: Rainer Mahlamäki (chairman, Finland), Gunnel Adlercreutz (Finland), Glenn Murcutt (Australia), Unto Siikanen (Finland) and Gert Wingårdh (Sweden).

We would also like to thank all our supporters and sponsors for their contribution to the success of this endeavour. We would like to give special mention to the Finnish Forest Foundation, The Finnish Forest Association, MTV3 Television Company, the City of Lahti, the Directors of Sibelius Hall, the Time for Wood campaign, the performers at the Award ceremony, Gunnel Adlercreutz for her support in making this book and the publisher, Building Information Ltd.

The organiser hopes the Award will enhance respect for the use of timber in both construction and building components and that it will also lead to an improvement in their quality.

Erkki Toivanen

Chairman

Advisory Committee of The Wood in Culture Association

Naming the Winner

RAINER MAHLAMÄKI

architect SAFA

chairman of the jury

All juries find their task demanding and, often, very difficult. So it was with the jury of this competition who carried out several lengthy and evolving discussions about the grounds of the Prize and the merits of the candidates. As there is no other international wood prize in the world the jury was very conscious of its responsibilities: the discussion that would follow the first-ever awarding of the Prize would in part create the ground on which subsequent winners would be chosen. This meant that the task at hand was more demanding but, simultaneously, more interesting than is usual.

Wood is a familiar material to Finnish architects. We have all used it, the raw material grows and regenerates all around us. For this reason it is natural for a Finnish public body to found a prize which underlines the significance of wood in creating good architecture.

Choosing the first winner of the Spirit of Nature – Wood Architecture Award was to be a difficult and challenging task for the jury. The process of considering candidates proved – as the jury had guessed – that as far as contemporary architecture is concerned, wood is a relatively sparsely used and a surprisingly difficult material. A general observation was that only in a few cases had the use of wood lead to an interesting and controlled architectural whole. And yet, from amongst the many notable contemporary architects, a few surprising names surfaced; architects whose works contained impressive examples of the use of wood as a key element in design. It was also a delight to discover, often by young architects, many one-off, fresh and high-quality designs which highlight the intrinsic qualities of wood. This leads us to believe that the recognition imparted by the Spirit of Nature – Wood Architecture Award will give it a distinct position with regard to other awards within the profession.

The jury set out to find the first winner of the prize with no preconcep-

tions. It carried out broad discussions about the nature of architecture and its role, about materials and their characteristics. The task of finding the first winner of the Spirit of Wood Architecture Award was, however, surprisingly easy considering the number of both internationally renowned and younger, less established architects to choose from. The unanimous decision was Renzo Piano (b. 1937). His design work, spanning over four decades, evidences a consistent body of work characterized by simplicity, natural structural logic and careful attention to detail. All this, combined with a deep understanding of each brief, site and cultural context lifts Renzo Piano into the group of great architects.

Renzo Piano has created his name mainly through his larger works like the Pompidou Centre in Paris (Rogers & Piano 1977). What is less known is that besides the Pompidou and other designs in steel, aluminium and glass, he has also designed wooden structures: innovative and subtle buildings which are also of a high technical standard. Renzo Piano's work is an excellent example of the importance of a thorough knowledge of the materials being used as the basis of a sustainable, aesthetic and ethical architecture. His designs show how the most interesting qualities of wood – particularly in the case of structures – are allowed to surface when wood is used in conjunction with other materials; thus utilizing the best qualities of each material.

The core of Renzo Piano's innovative and tectonic architecture can be seen in the IBM Travelling Pavilion (1986). A portable (now unused) building, the load-bearing frame consists of glu-lam arches with the intermittent spaces between the arches being transparent sheets of polycarbonate. The two materials, very different in quality, have been joined together with brackets and a special glue developed for the

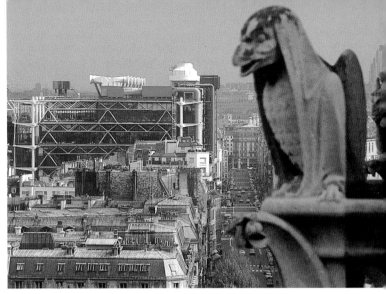

CENTRE POMPIDOU 1971–77

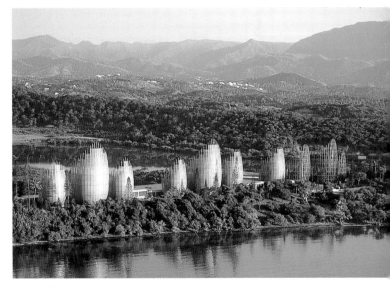

TJIBAOU CULTURAL CENTER 1991-98

project. In its unaffected simplicity the refined and repetitive series forms a rich pattern. The Prometeo Musical Space (1984) also makes use of the same theme: a mobile performance space for music with a glu-lam structure, the completed wooden structure resembles a mythical ark or vessel.

Renzo Piano's designs grow out of their surroundings. His present office is located in the UNESCO Research Laboratory (1994), near Genoa. The spaces, placed along the side of a hill, slide seamlessly into the surrounding nature and open up towards the sea. The simple, light-

filtering roof structure consists of glu-lam beams and light steel supports. The Jean-Marie Tjibaou Cultural Centre in New Caledonia (1998) and its form language grows out of the culture and life of the local indigenous people. This building too has wood as its main material, the use of which implies local building traditions. Ten arching pavilions, with glu-lam structures and timber cladding form a sculptural group of buildings which exude mystery. The pavilions turn their backs to the sea and its accompanying winds but at the same time are designed to benefit from the natural air-conditioning of that wind. These two projects in particular show not only a restrained, rich and varied side to Renzo Piano's architecture but also the technical, aesthetic and ecological opportunities that wood can offer an architect.

On behalf of the jury I would like to thank the organizer, the Wood in Culture Association for initiating the extensive process of founding this prize. We firmly believe that it will have an important role as one of the major international architectural awards and as such will emphasize and promote the qualities of wood as an ecological, inspiring, workable and infinitely refinable material for high class architectural solutions. This Finnish award and the annual musical events in the Sibelius Hall Congress and Concert Centre in Lahti it is linked to, emphasize the width of the concept of culture and its possibilities for exchange. An approach it also transmits internationally.

For this first award ceremony and for the future profile of the Spirit of Nature – Wood Architecture Award, it was of the utmost importance that regardless of the tight timetable a publication could be put together. The publisher wants to emphatically thank Renzo Piano's office for producing and transmitting material at such short notice.

Finally, on the behalf of the whole jury, I want to congratulate Mr. Renzo Piano. It is a pleasure and a privilege to be able to present him with this first Wood Architecture Award.

The Spirit of Place

GLENN MURCUTT

architect

member of the jury

Renzo Piano has said that 'the universality of technology has the potential to destroy the spirit of place, yet place is local and must not inhibit the potential of technology'. In his substantial body of work he demonstrates that inspiration can be drawn from cultural sources of low-tech traditional buildings and at the same time avoid the picturesque.

Together with his collaborators, Piano has throughout his career worked in the spirit of trial and error, experimenting with technology and structures through his observations of nature. This has led him to prefabrication systems and purpose designed components. He works in a 'constant cyclical process' of design, engineering calculations, detailing, modelling, full size mock-ups and redesign.

Piano's preference is for the making of things over his interest in engaging technology as an end in itself. His is an architecture which explores not only engineering ideas but also the craft required to make poetic relationships with form and materials.

He has always eshewed style, the look of a building, as his primary concern. Rather, he regards style as a dangerous concept. It's a narcissistic approach. One needs to worry about coherence. That is a better idea. ... Style becomes a limitation, a sort of golden cage in which you worry about being recognised.

His work embodies the aspirations of his clients, their sites, climes and cultural contexts.

Piano's architecture is technologically innovative, elegant, light, often transparent, legible and simple, balanced with modern building systems and capabilities. The work incorporates a composite of materials such as wood with metals and fabrics making often remarkable conjunctions that ensure their forms reveal the purpose and nature of each element developed.

Jean-Marie Tjibaou
Cultural Centre

Nouméa, New Caledonia
1991-98

At the request of New Caledonia, the French government agreed to finance the construction in Nouméa of a centre devoted to the memory of the political leader, Jean-Marie Tjibaou, who was assassinated in 1989.

The major challenge behind this project was the task of paying homage to a culture; respecting its traditions and history – past, present and future – as well as its sensitivities. This meant putting European technology and expertise at the service of the traditions and expectations of the Kanaks. By no means should it be a parody of this culture, but nor should it involve imposing a totally foreign model.

The idea was that, instead of creating an historical simulation or a simple replica village, it was preferable to strive to reflect the indigenous culture and its symbols which, though age-old, were still very much alive.

An understanding of the development of Kanak culture was a vital part of this project, becoming familiar with the Kanak's history, environment and beliefs would make it possible to remain as faithful as possible to the peoples' traditions.

Concretely, that meant using traditional materials and building methods as well as respecting and drawing on certain natural elements, such as wind, light and vegetation.

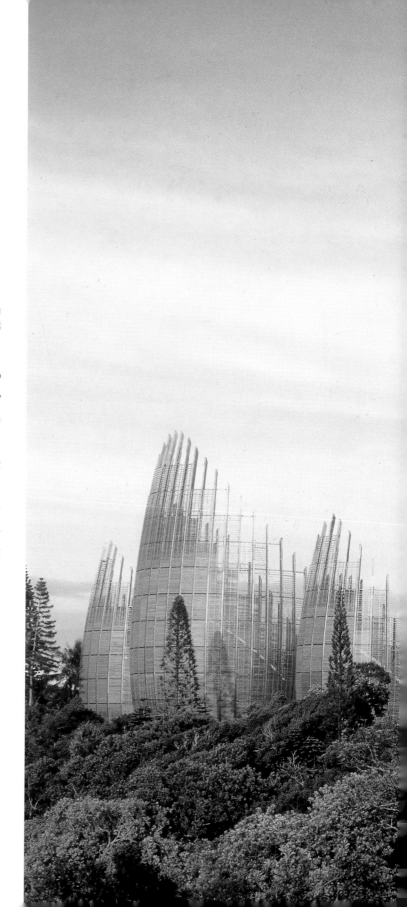

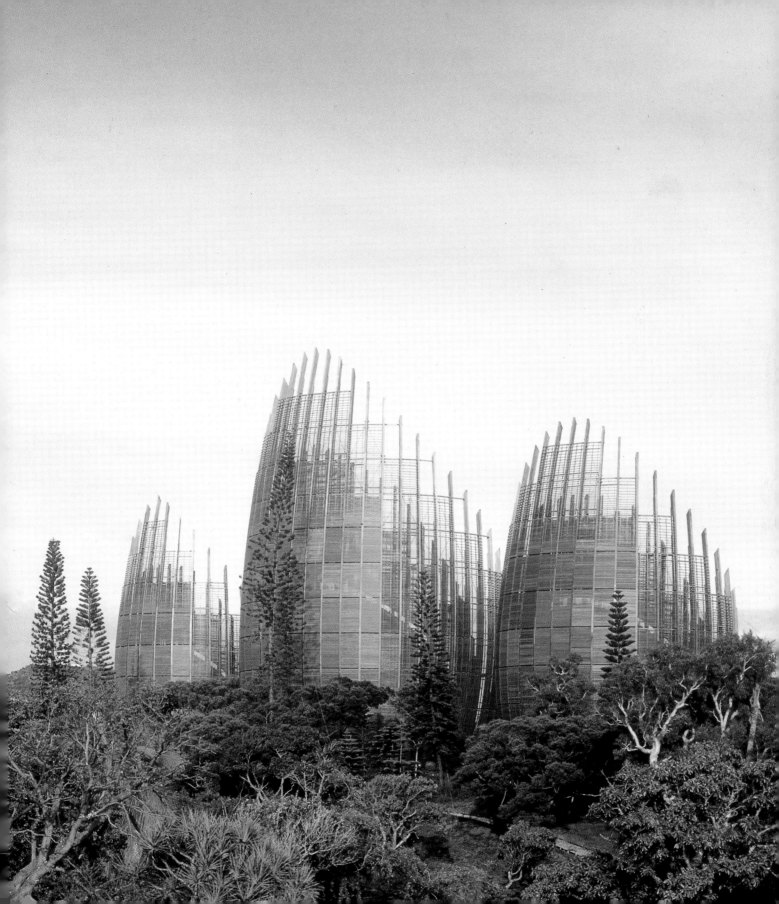

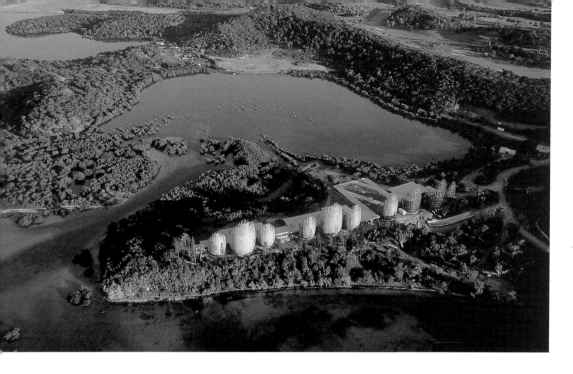

The structure and above all the functionality of New Caledonian huts were adapted and reproduced. There are ten huts in all, each measuring between 20 and 28 metre in height, at the centre of a nature reserve situated along the ocean shore. Each is linked to a footpath.

These huts serve various functions or evoke certain themes. Part of the site is devoted to permanent or temporary exhibitions and contains an auditorium and an amphitheatre. Housed in a second series of huts are, aside from the administrative departments, research areas, a conference room and a library. The last series of huts contains studios for traditional activities, such as music, dance, painting and sculpture.

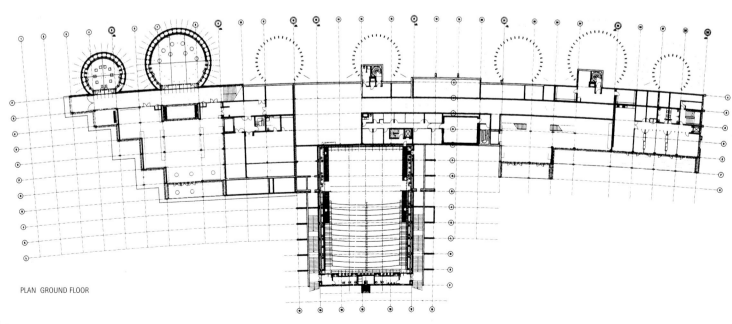

PLAN GROUND FLOOR

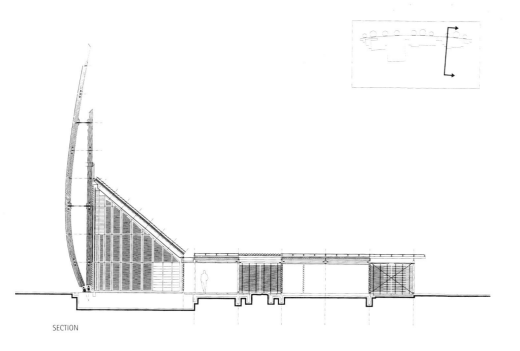

SECTION

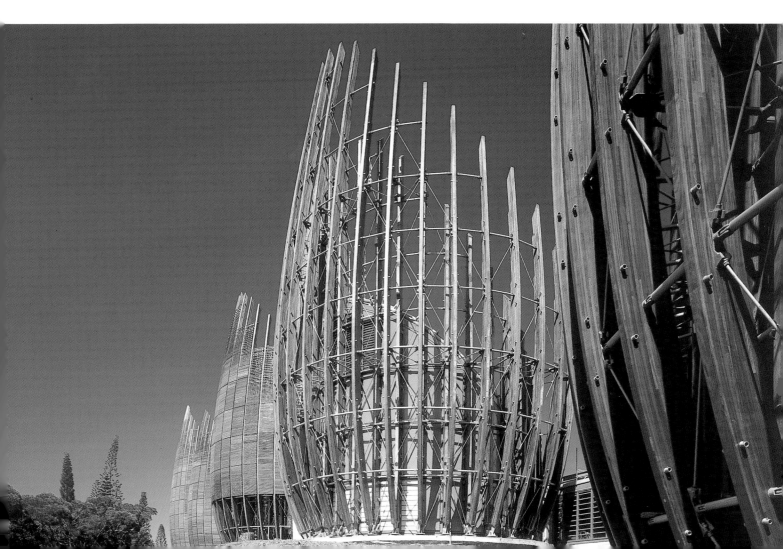

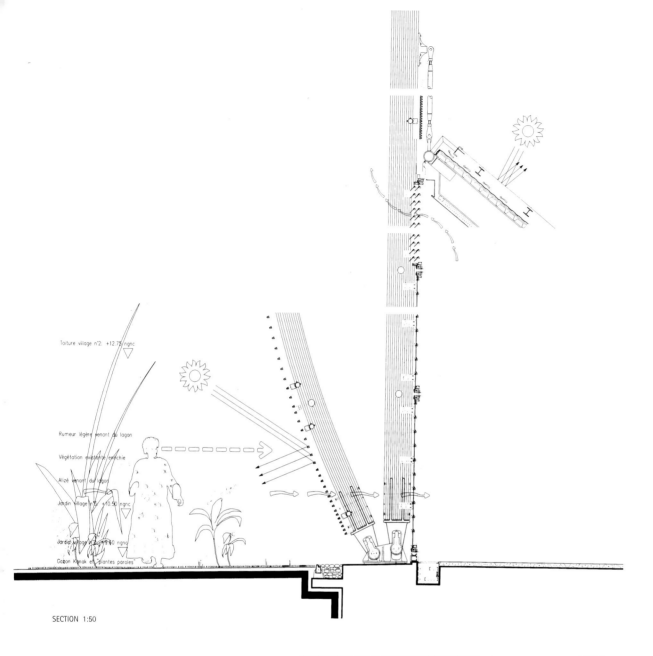

Toiture village n°2: +12.75 ngnc

Rumeur légère venant du lagon

Végétation existante enrichie

Alizé venant du lagon

Jardin village n°1: +10.50 ngnc

Jardin village n°2: +9.50 ngnc

Gazon Kanak et plantes paroles

SECTION 1:50

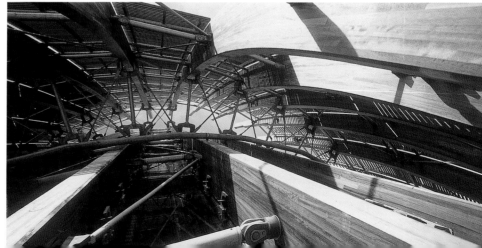

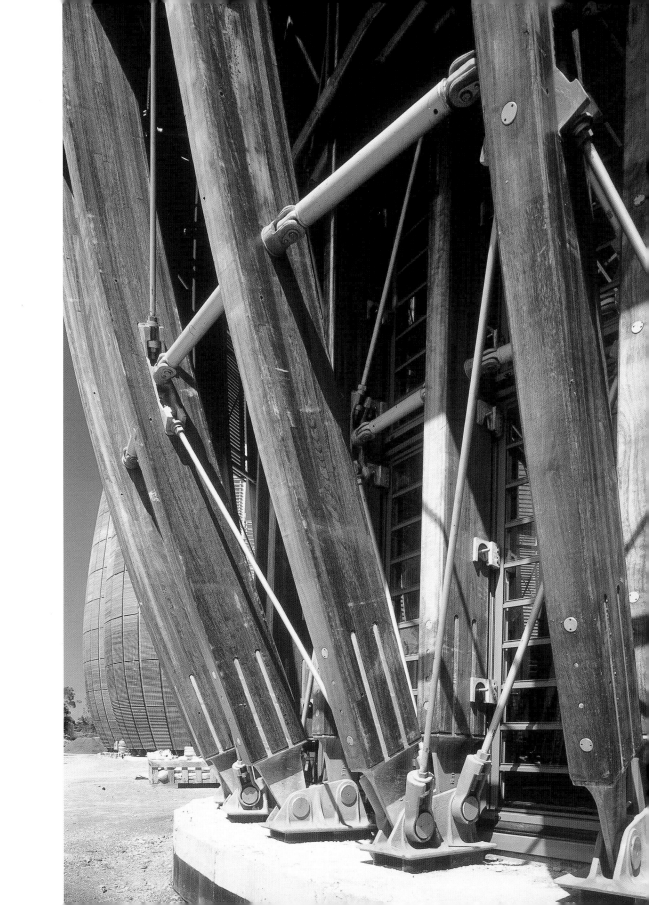

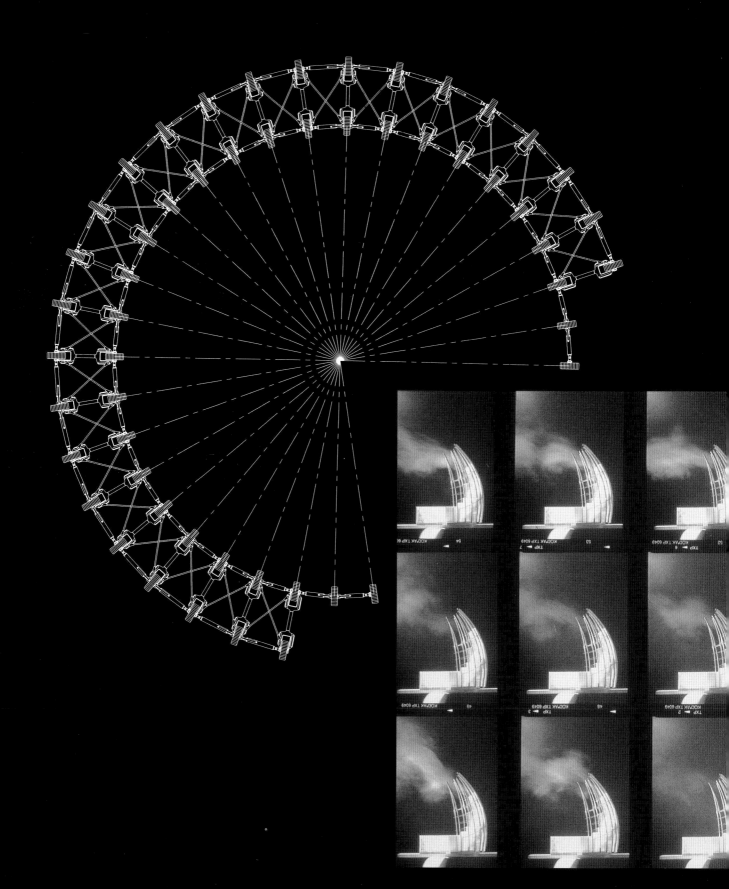

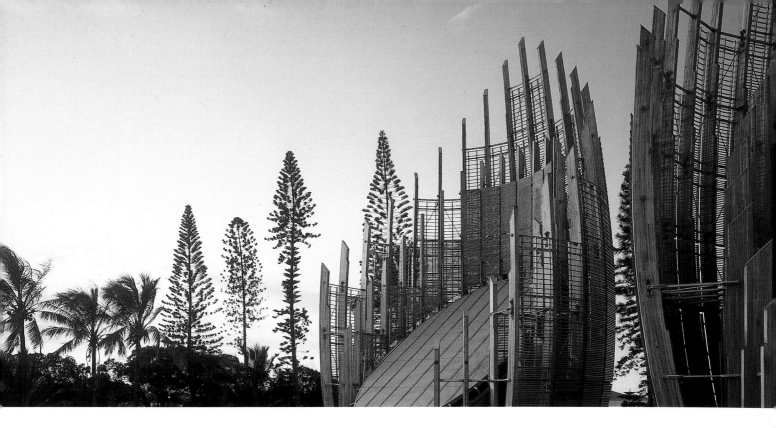

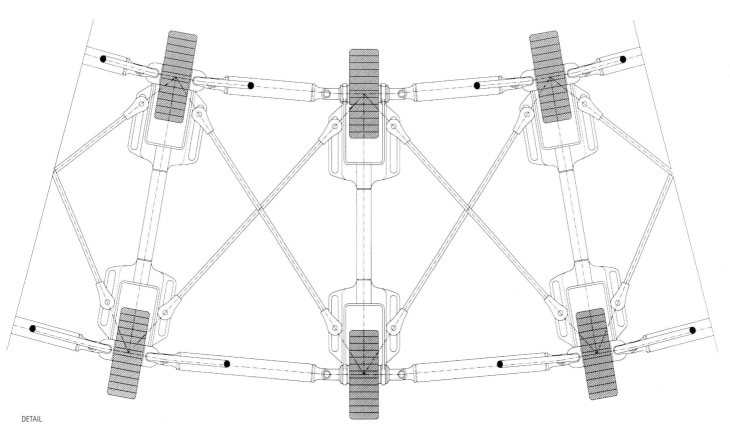

DETAIL

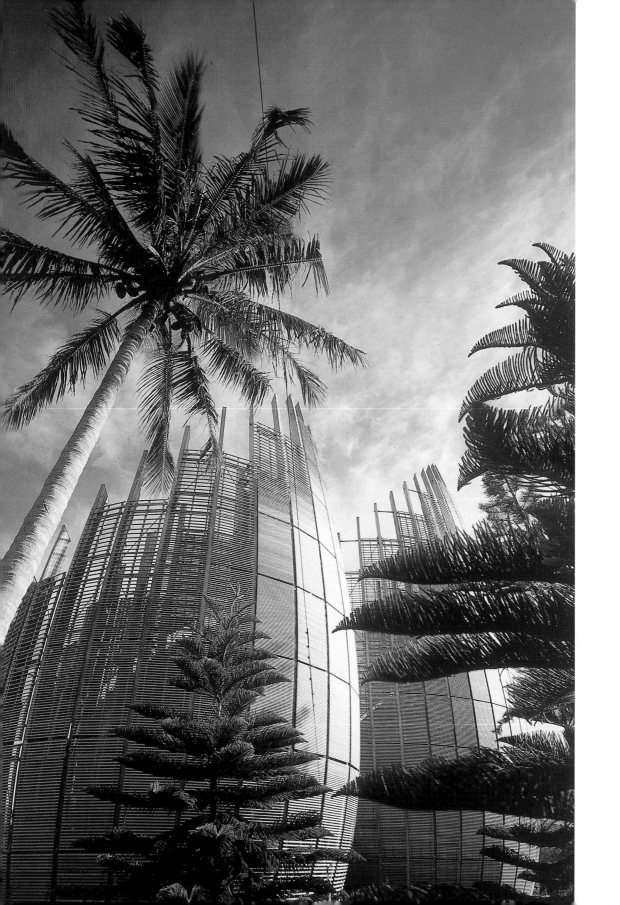

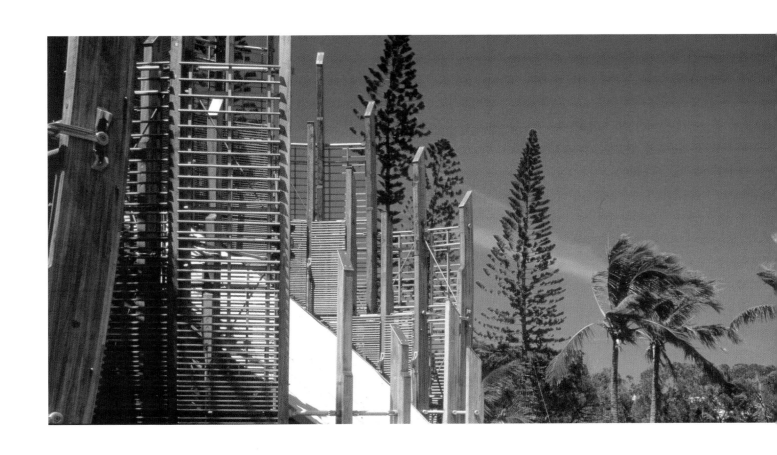

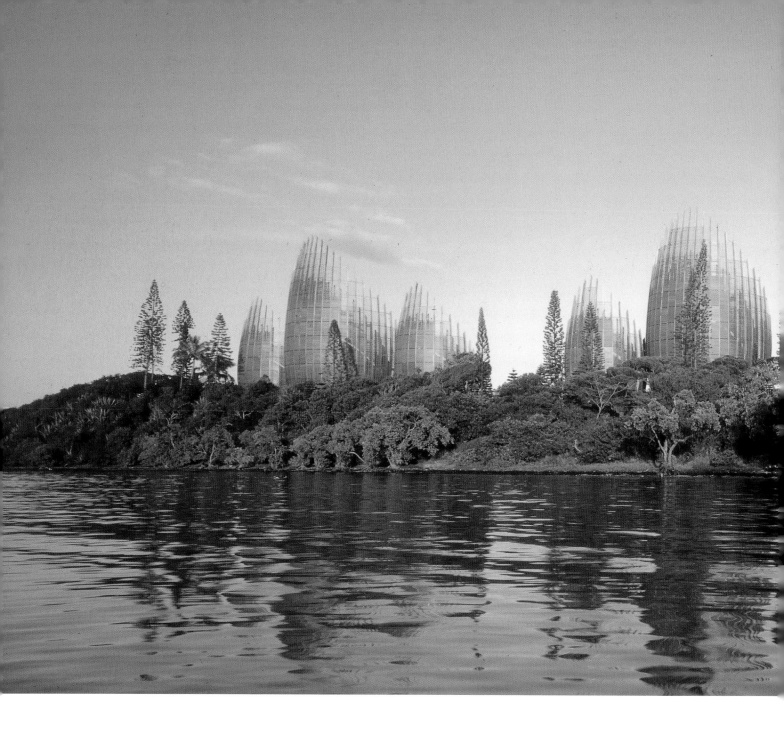

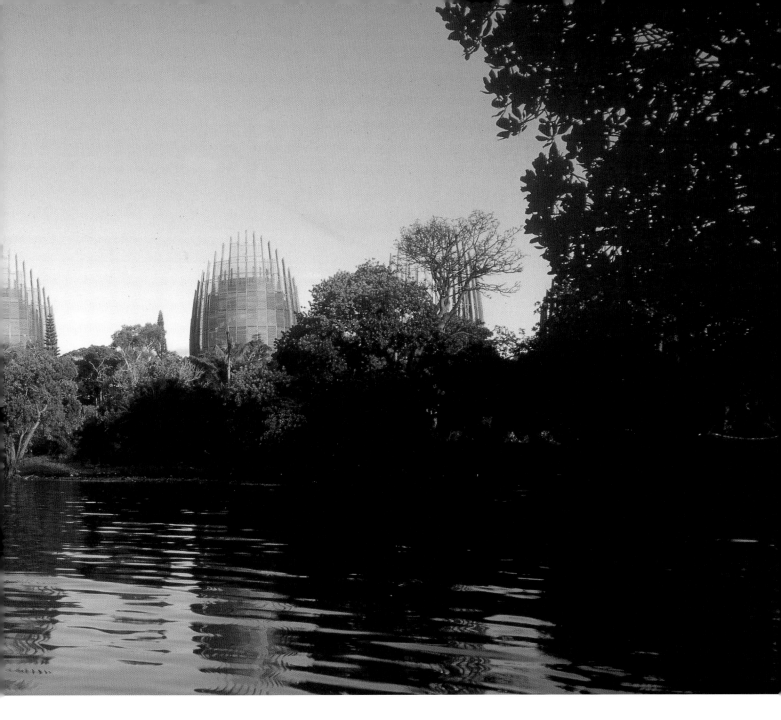

Renzo Piano
Building Workshop

Joint Research Programme Laboratory
Punta Nave, Genoa, Italy
1989-94

Perched on a hill surrounded by the sea, Punta Nave houses both a UNESCO research lab and the Genoa headquarters of the Renzo Piano Building Workshop. Built in 1989 toward the western edge of Genoa, the site has been purposely isolated like a desert island. It invites calm, silence, concentration and creativity. It is not, however, a hermitage: people of all different nationalities work here, and the door is always open to colleagues.

Punta Nave is in perfect harmony with its surroundings. Set on a gently sloping site the Workshop is a series of terraces which open onto the sea. They are built of glass and are exact replicas of traditional greenhouses found on the Ligurian coast. Lying between the mountain and the Mediterranean Sea, Punta Nave stands as a homage we wished to give to the sea.

The Workshop is an immense greenhouse overrun, inside and out, by all types of plants and greenery, creating the feeling of a privileged communion with nature. In the same spirit, we sought to take maximum advantage of the natural light that pervades every aspect of life here and which has rapidly become our natural clock.

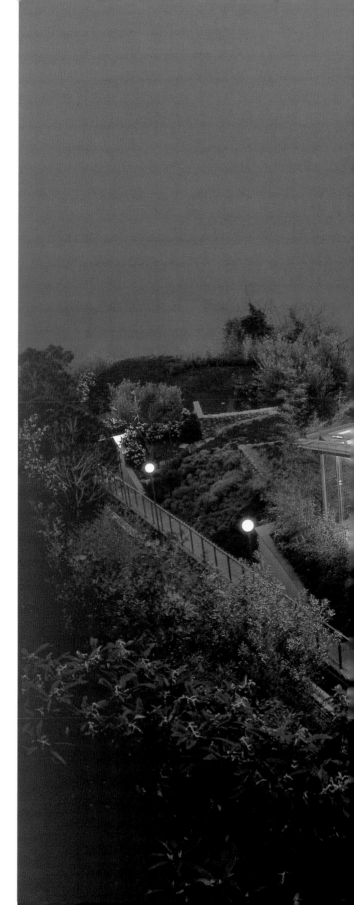

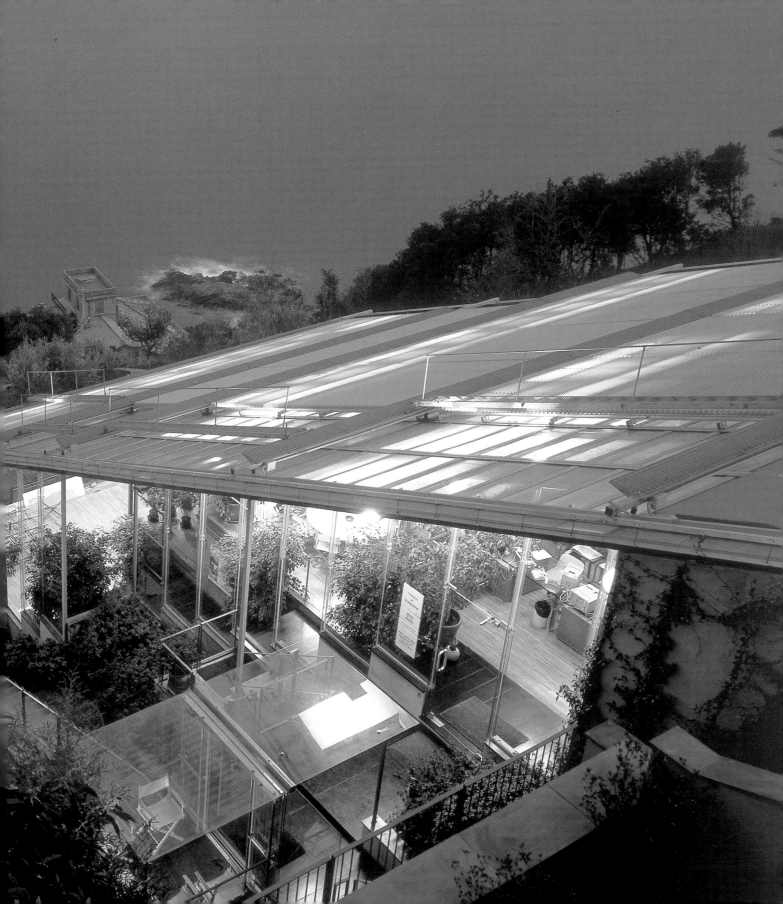

Whilst Punta Nave is a refuge deliberately set away from the centre, it can nevertheless communicate in real time with the rest of the world thanks to new technologies. It is therefore not really in opposition to the city; it is what we prefer to call a post-urban research centre.

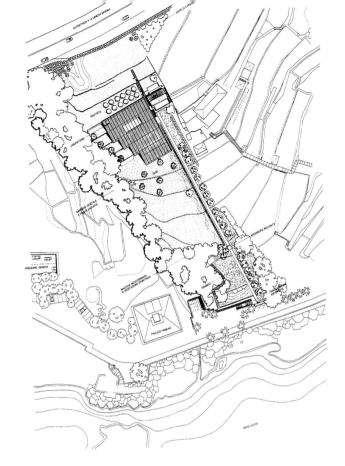

SITE PLAN 1:2000

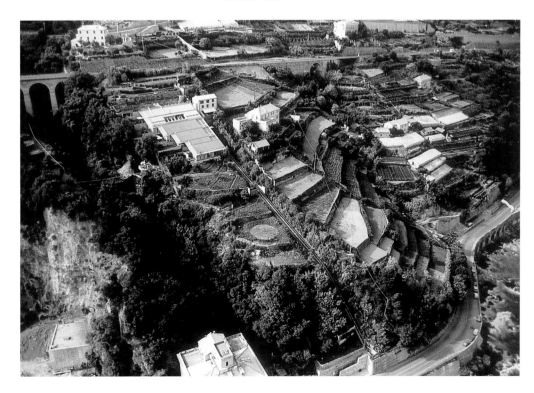

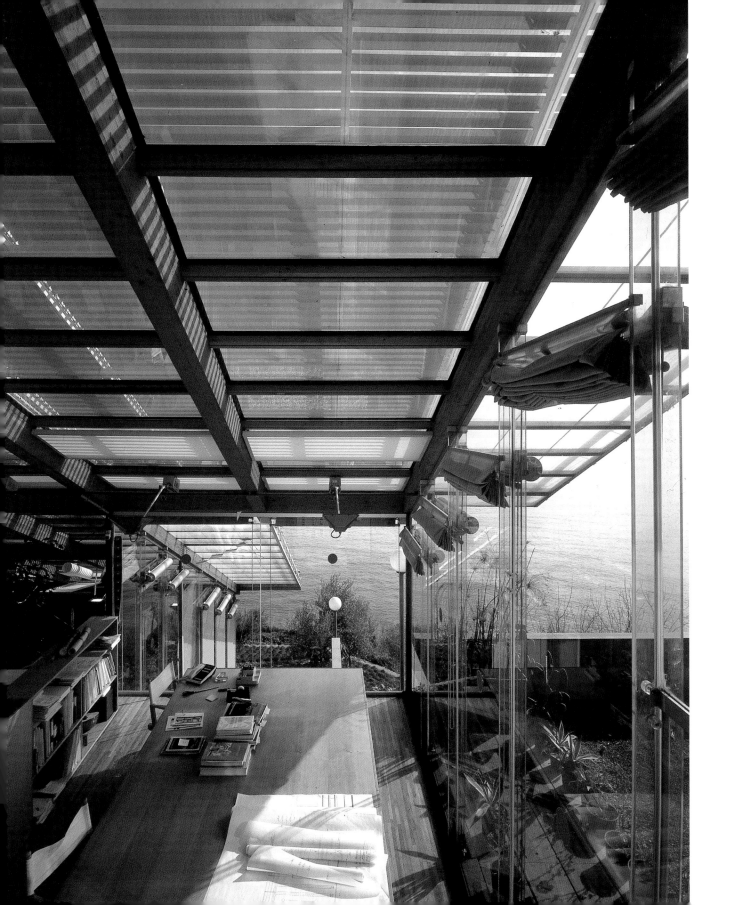

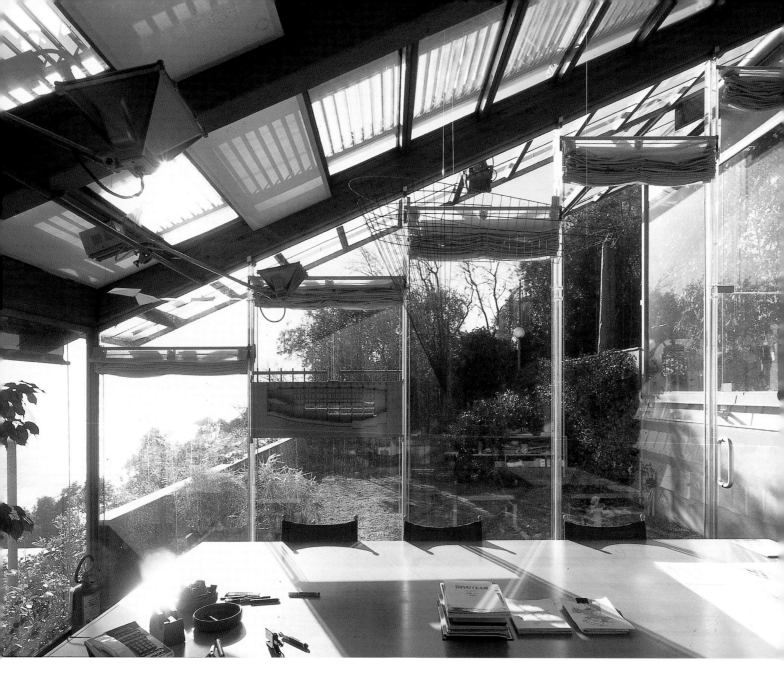

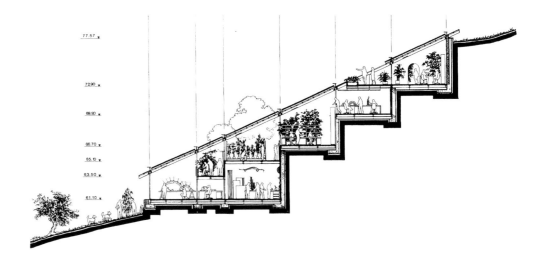

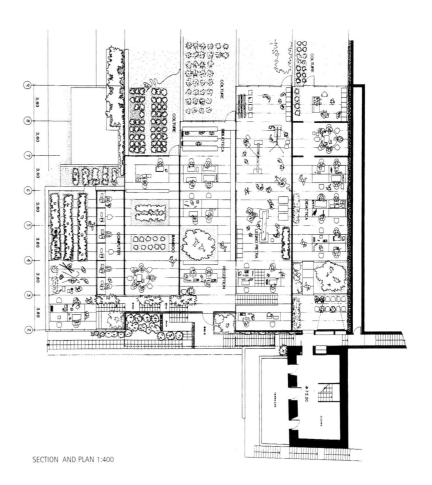

SECTION AND PLAN 1:400

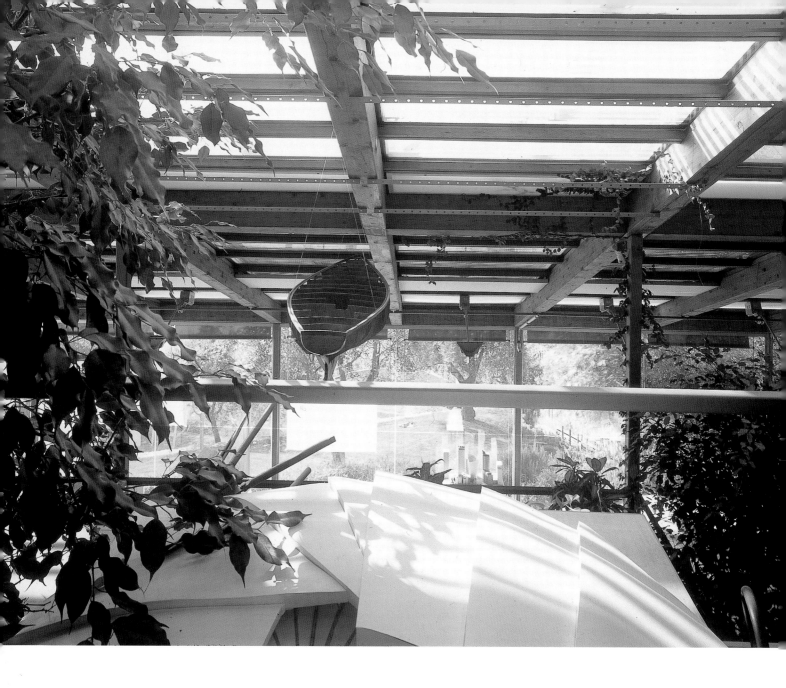

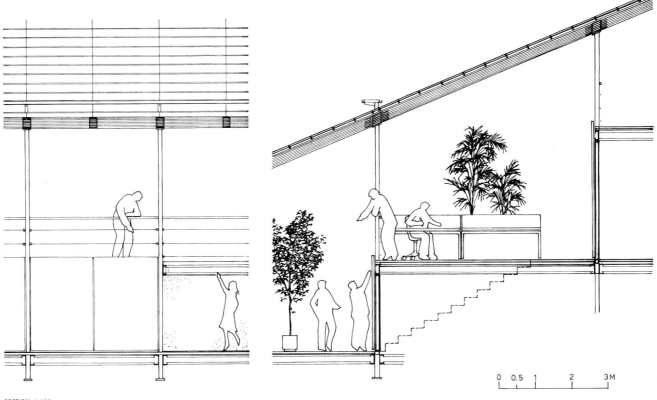

0 0.5 1 2 3M

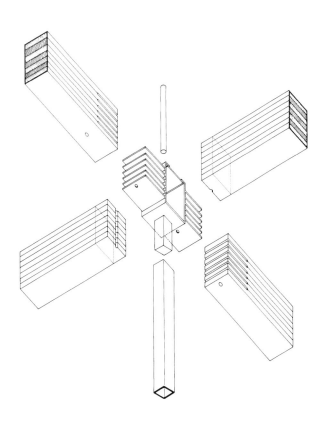

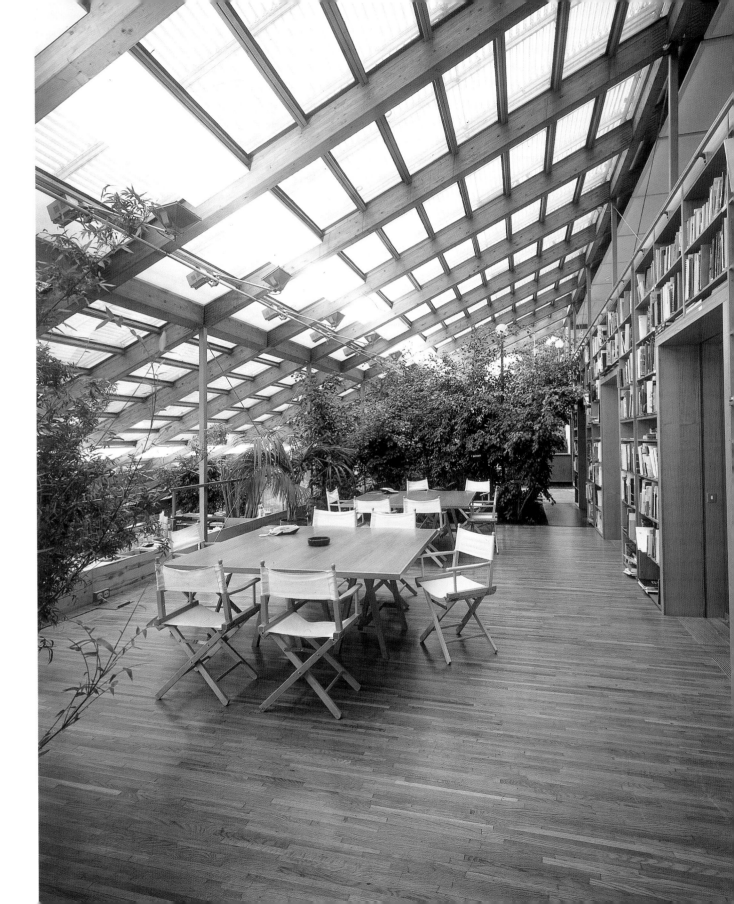

Prometeo
Musical Space

Venice and Milan, Italy
1983-84

Prometeo, written by Luigi Nono, is an opera that has close ties to both architecture and contemporary music. The goal of the project was to create a "musical" space that defies the way in which music halls have traditionally been perceived.

The audience are placed at the centre of the structure, and the musicians are spread at various heights round about them. The idea was to create a natural interaction at different points between the space and the music: one existing by virtue of the other.

Achieving this effect entailed creating a stage and a music hall but also a production and sound box. Another major aspect of this 400-seat structure is its modularity. It was to be constructed in a church in Venice as well as in an abandoned factory in Milan.

From a technical perspective this project offered challenges that went far beyond the mere problem of acoustics. The 80 members of the choir and orchestra must pass through passageways and stairways to access the three upper balconies lining the opera house. To follow the conductor, they watch special screens with multiple conducting cues.

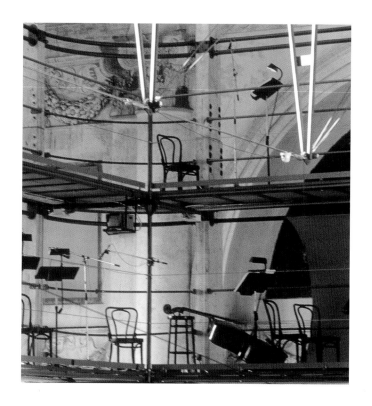

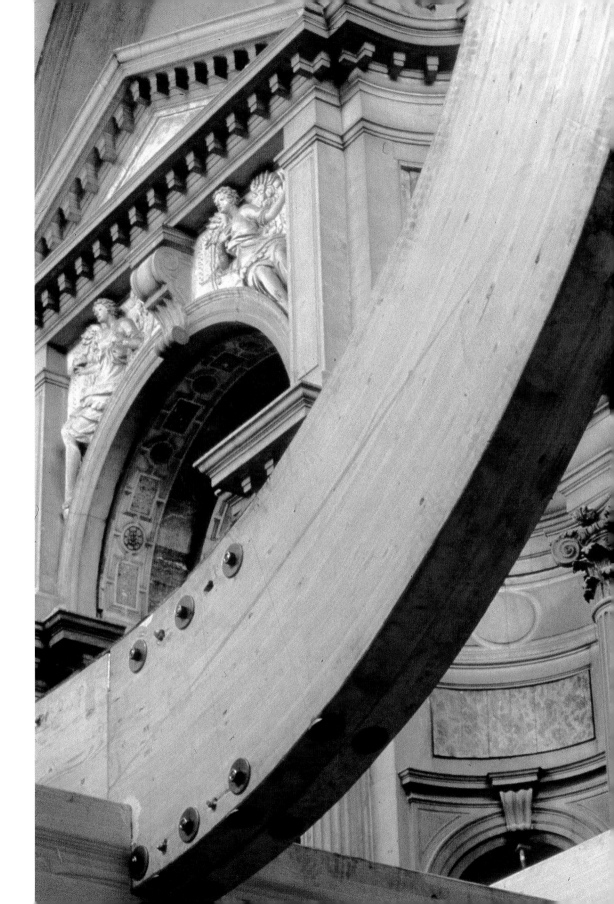

This space sprang from the opera which was an instrumental part of the creative process. Wood, selected for its acoustic properties, was the basic working material. Certain naval construction techniques were employed because of the sheer size of the project, in particular the use of glue-laminated wood.

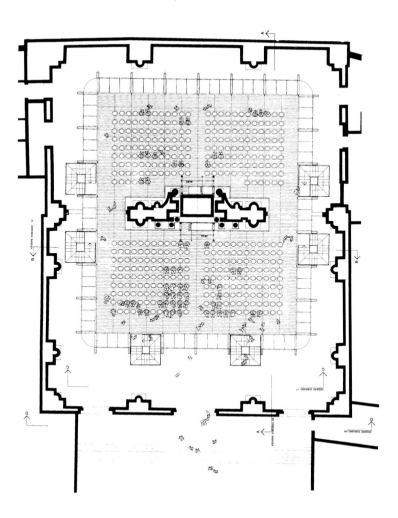

PLAN AND SECTION B 1:400

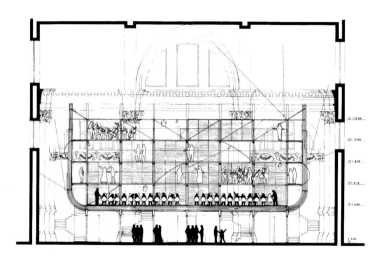

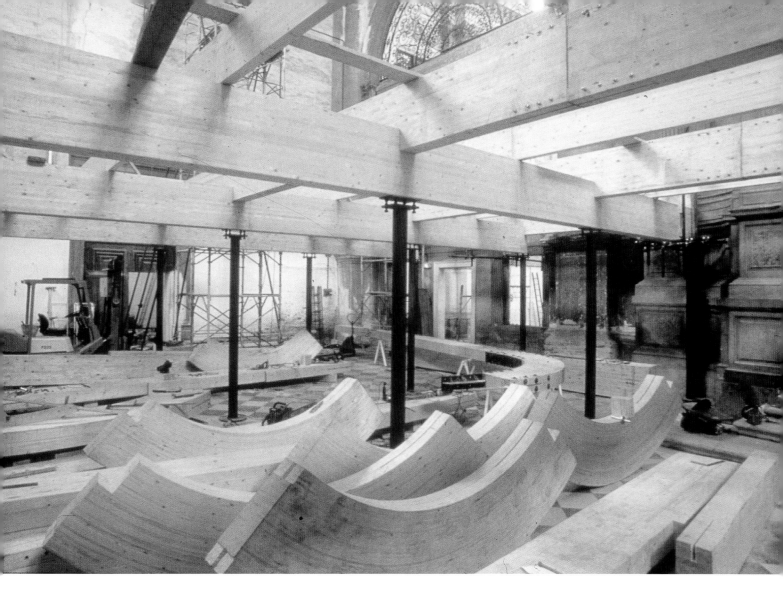

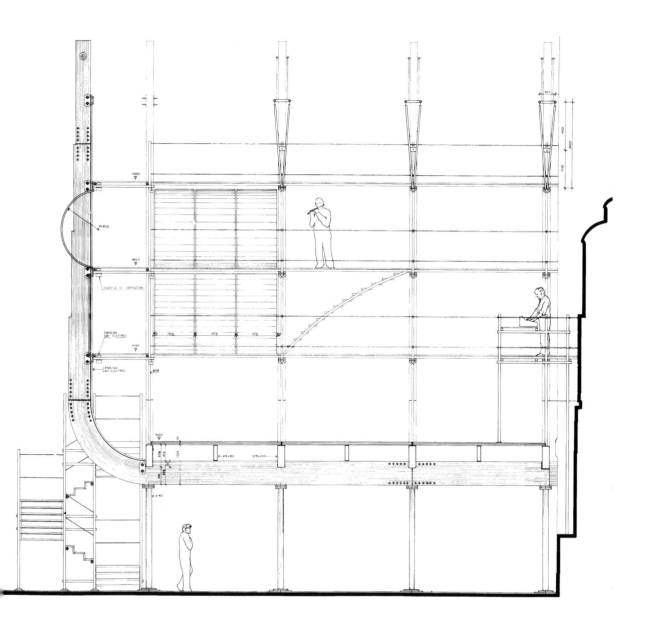

SECTION 1:100

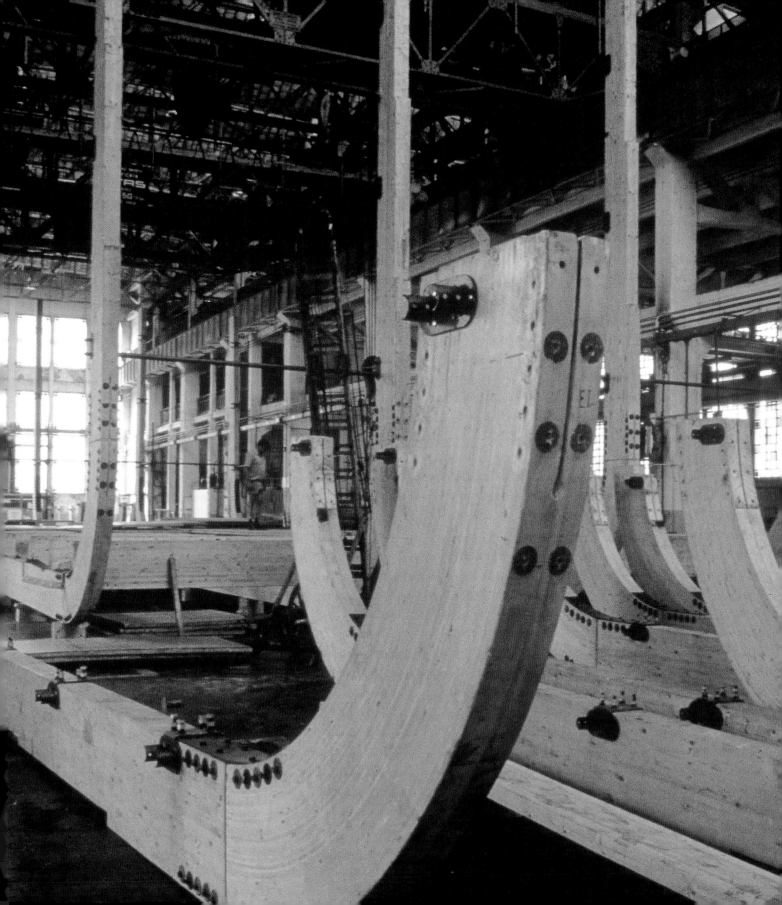

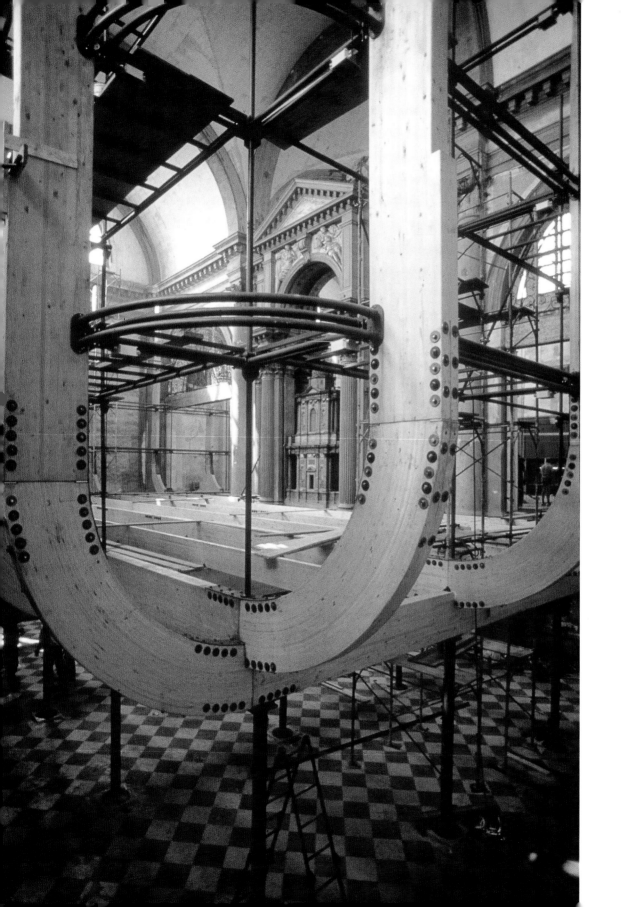

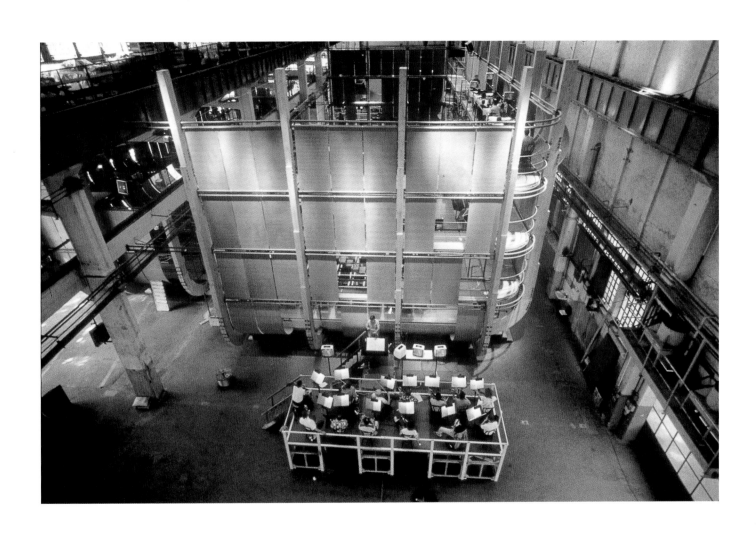

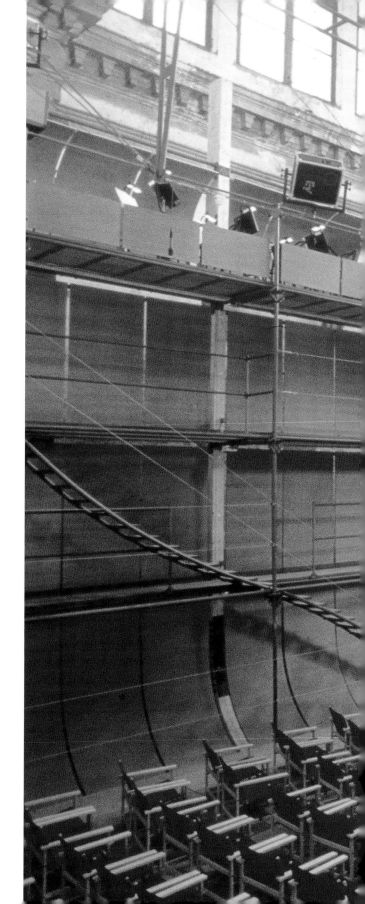

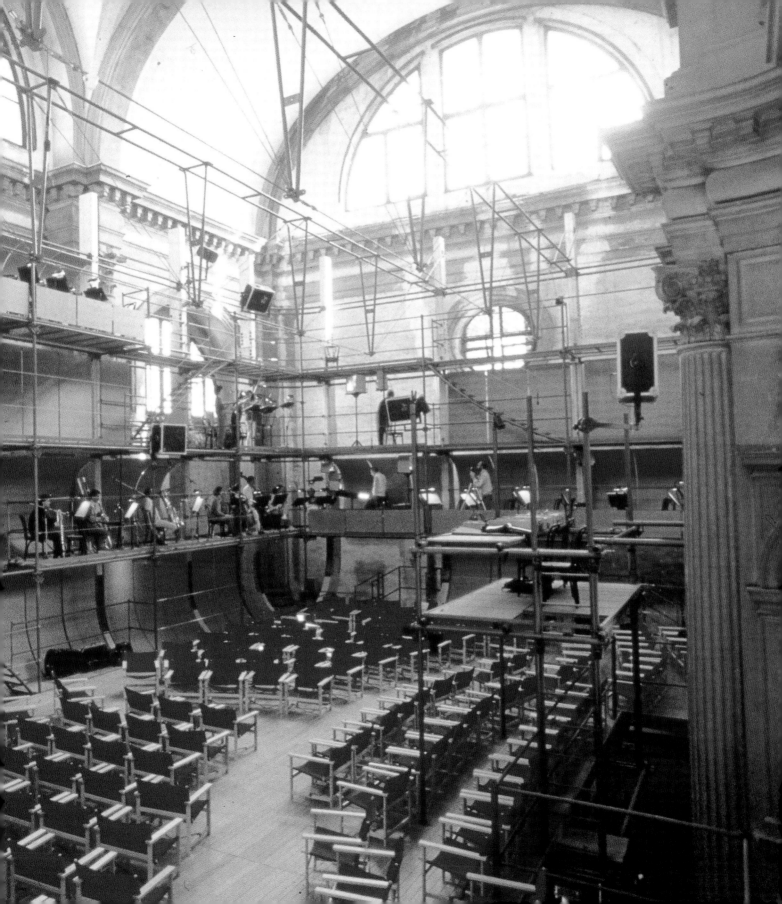

IBM Travelling Pavilion

1983-86

As part of its effort to promote advances in computer technology, IBM decided to organize a travelling exhibition across Europe. The exhibition's basic message focused on telecommunications technology (which obliterates many traditional barriers of distance and makes it possible to work from work stations located virtually anywhere) at a time when it was available to only a privileged few.

In keeping with the spirit of this approach, it was important that the exhibition should not be held in existing buildings, but rather in its own specially-designed pavilion that would remain identical at each stop on the itinerary. It would be assembled and disassembled in parks in various European cities, exactly as if it were the Big Top in a travelling circus. Building such a temporary structure meant that there was a lot of room for experimentation, mainly because the exhibit's temporary nature removed a certain number of constraints.

The pavilion, which was intentionally demolished at the end of its tour across Europe, was 48 metres long, 12 metres wide and 6 metres high.

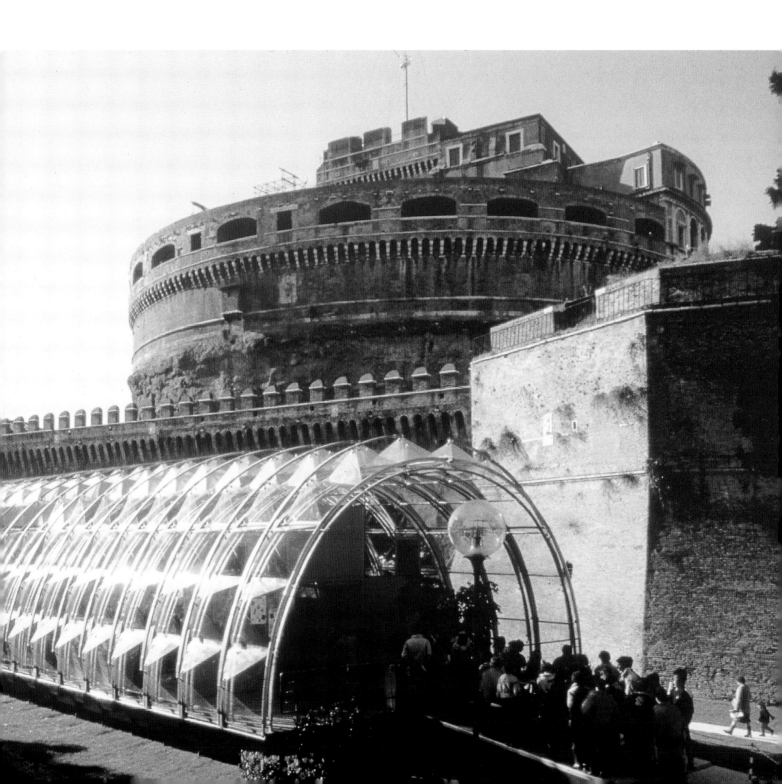

FACADE AND ROOF PLAN 1:400

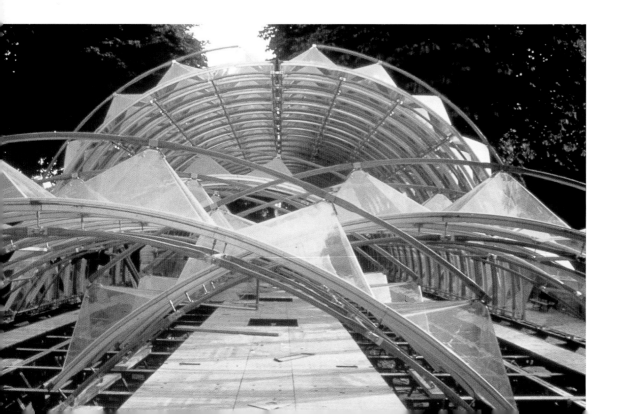

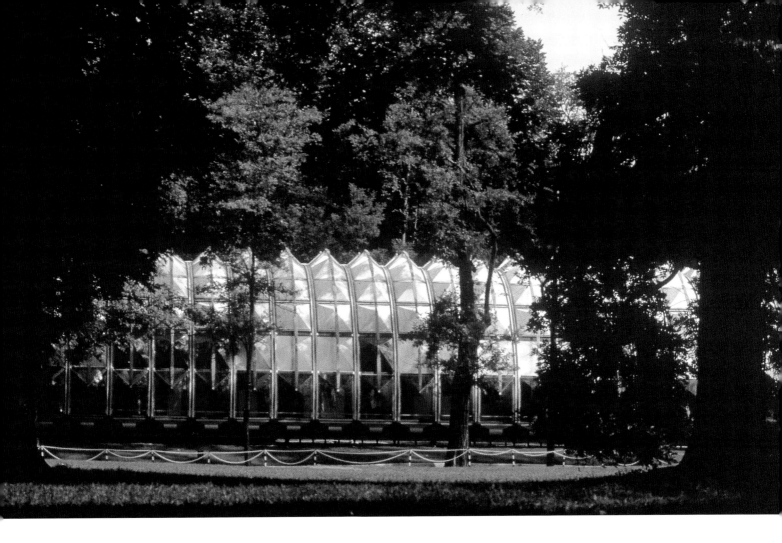

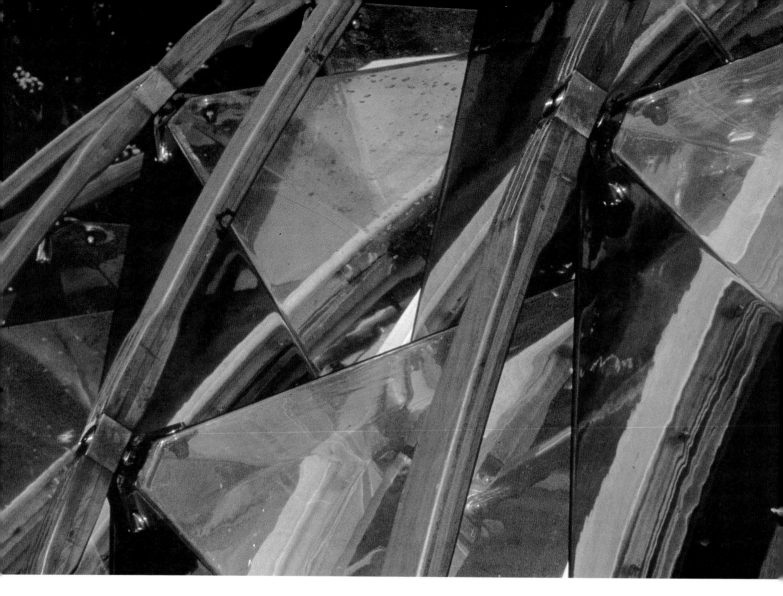

The structure consisted of a row of 44 geometrically uniform arches, each made up of 2 quadrants joined at the apex. The entire semi-cylindrical surface of the building was made of a transparent, very light but resistant polycarbonate material. Attached to the outer face of each quadrant were six pyramidical elements of this material; each held in place by supports made of laminated wood and cast aluminium joints.

One of the innovations developed especially for IBM's travelling pavilion was a brainchild of modern chemistry: ultra-strong adhesives made it possible to glue together the pavilion's radically different materials.

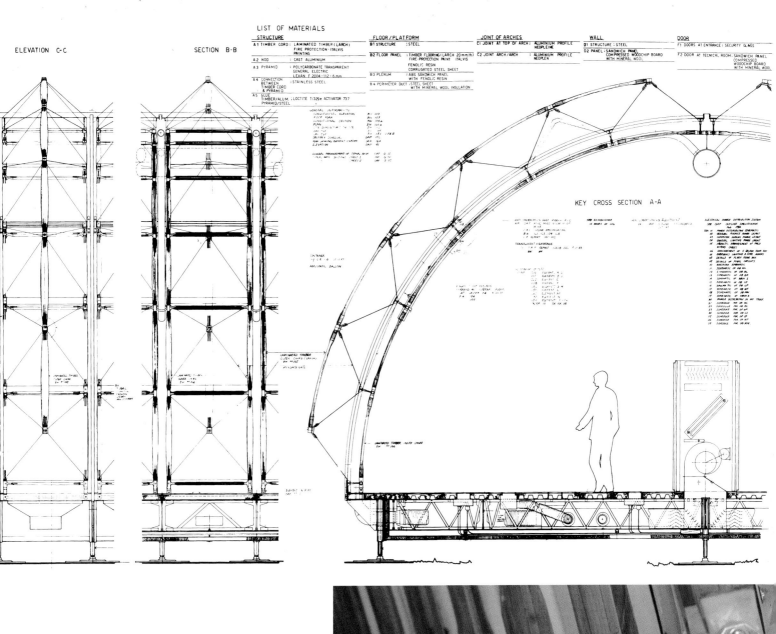

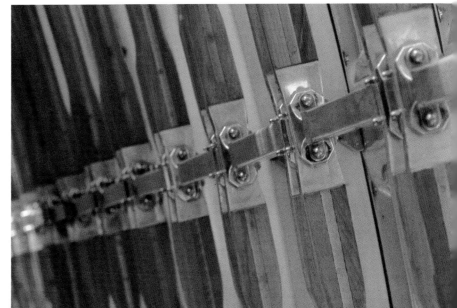

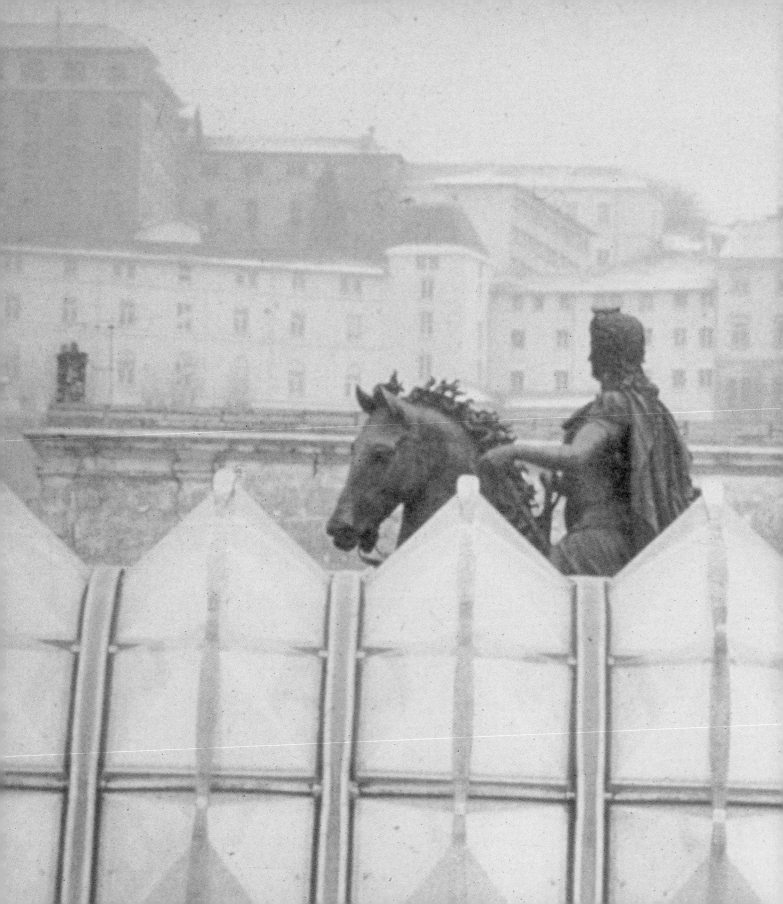

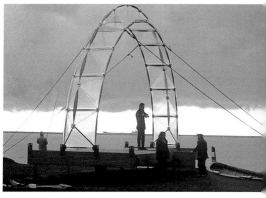

Menil Collection

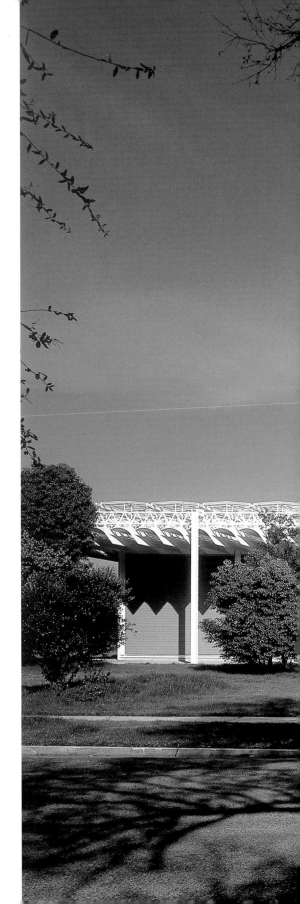

Museum
Houston, Texas, U.S.A.
1981-86

The Menil Collection is a museum that was designed at the behest of Dominique De Menil, who wanted to open her private collection, which includes more than 10,000 works of primitive and contemporary art, to the general public. Her wish was to create an experimental museum that would consist of a restoration workshop, art galleries and a village, all the while drawing upon the widest possible use of natural light.

The 10,000 works in the collection are displayed alternately. They are stored in the "Treasure House" on the second level (a protected, climate-controlled site separated from the first-level exhibition galleries) and then displayed for short intervals. By exhibiting the works in this way, it is possible to expose them, at least temporarily, to higher than normal levels of light (around 1000 lux).

The roof of the museum is made of "leaf-like" modular elements thus allow light to pour in whilst filtering out ultraviolet rays. The transfusion of natural light through these leaves gives the rooms a changing character, unique at each moment, depending on the position of the sun.

In keeping with this desired effect the museum has a rhythmic, cellular plan with galleries opening onto enclosed gardens; all of which contribute to an overall feeling of a shimmering lightness. Hence, the museum becomes a place of calm and tranquil contemplation.

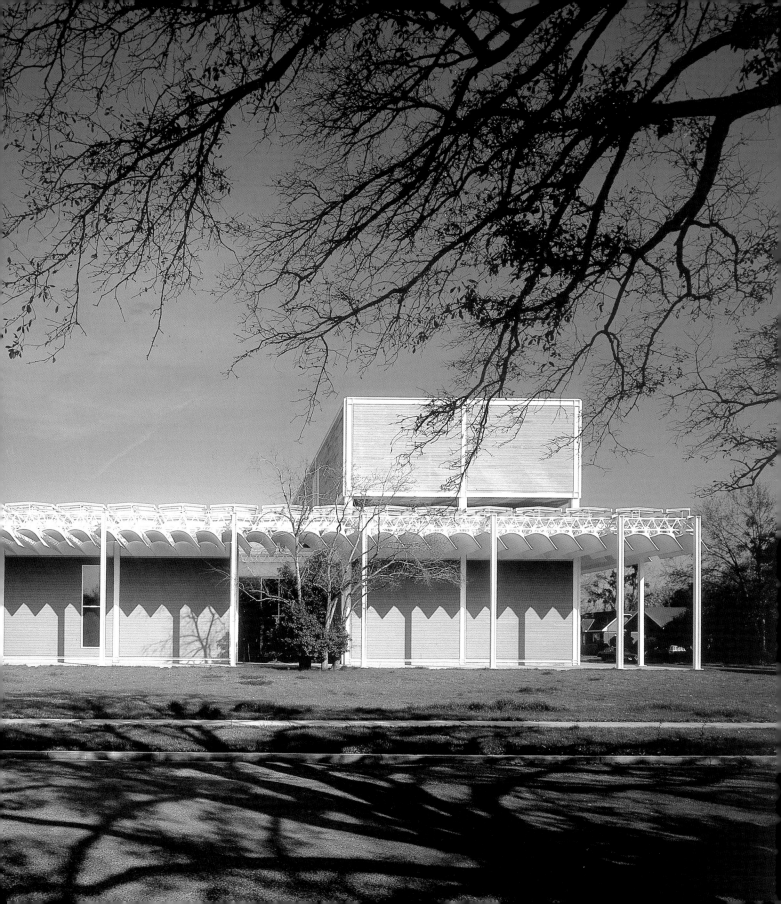

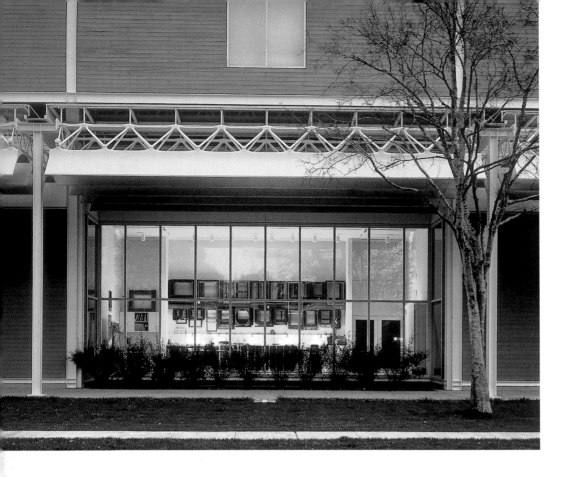

The museum is surrounded by trees, lawns and traditional houses, typical of the historic district of Houston. Some of the neighbouring houses serve as museum annexes for specific activities (book shop, administration, etc.). The building is modeled on the style of these houses, echoing their motifs or drawing on the same construction methods or materials. Without dominating and overshadowing the district, the museum fits in with its surroundings, as a "Museum village".

Again at the request of Mrs. De Menil, a permanent wing devoted to the work of Cy Twombly was constructed in 1992. This second museum has a stricter, more defined and discrete structure and it too avoids dominating the other houses. The artist wanted a square space that would be extremely simple, even spare, illuminated by light that was omnipresent but less direct and more diffuse than in the other museum, (at an intensity of about 300 lux).

SITE PLAN 1: 2000

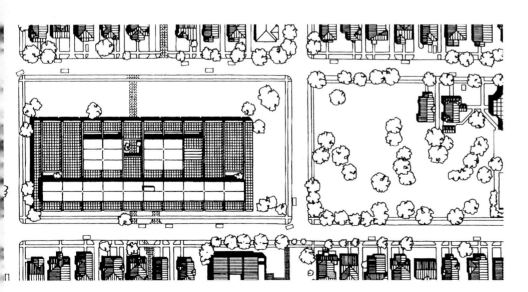

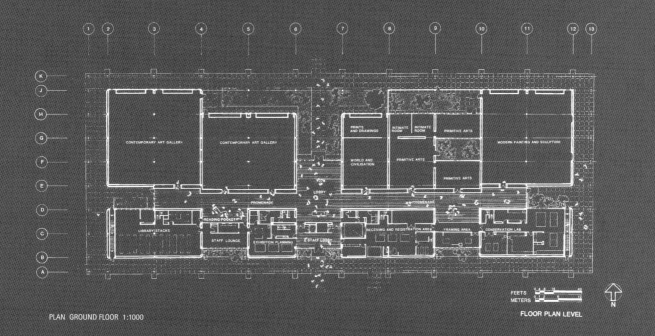

PLAN GROUND FLOOR 1:1000

CONTEMPORARY ART GALLERY

CONTEMPORARY ART GALLERY

PRINTS AND DRAWINGS

INTIMATE ROOM

INTIMATE ROOM

PRIMITIVE ARTS

MODERN PAINTING AND SCULPTURE

WORLD AND CIVILISATION

PRIMITIVE ARTS

PRIMITIVE ARTS

LOBBY

PROMENADE

PROMENADE

READING POCKET

LIBRARY/STACKS

STAFF LOUNGE

EXHIBITION PLANNING

STAFF LODGE

RECEIVING AND REGISTRATION AREA

FRAMING AREA

CONSERVATION LAB

FEETS
METERS

FLOOR PLAN LEVEL

N

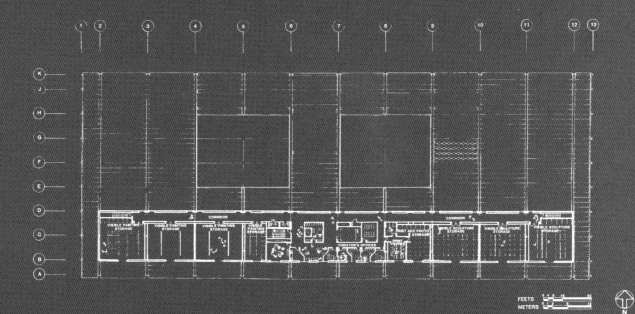

PLAN 1ST FLOOR 1:1000

VISIBLE PAINTING STORAGE

VISIBLE PAINTING STORAGE

VISIBLE PAINTING STORAGE

CORRIDOR

VISIBLE PAINTING STORAGE

PRINT VIEWING

CURATOR'S OFFICES

PRINT AND PHOTO STORAGE

CORRIDOR

VISIBLE SCULPTURE STORAGE

VISIBLE SCULPTURE STORAGE

VISIBLE SCULPTURE STORAGE

FEETS
METERS

TREASURE HOUSE PLAN LEVEL

N

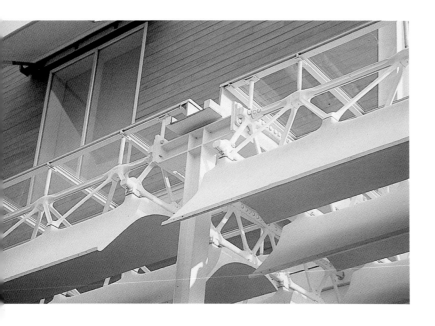

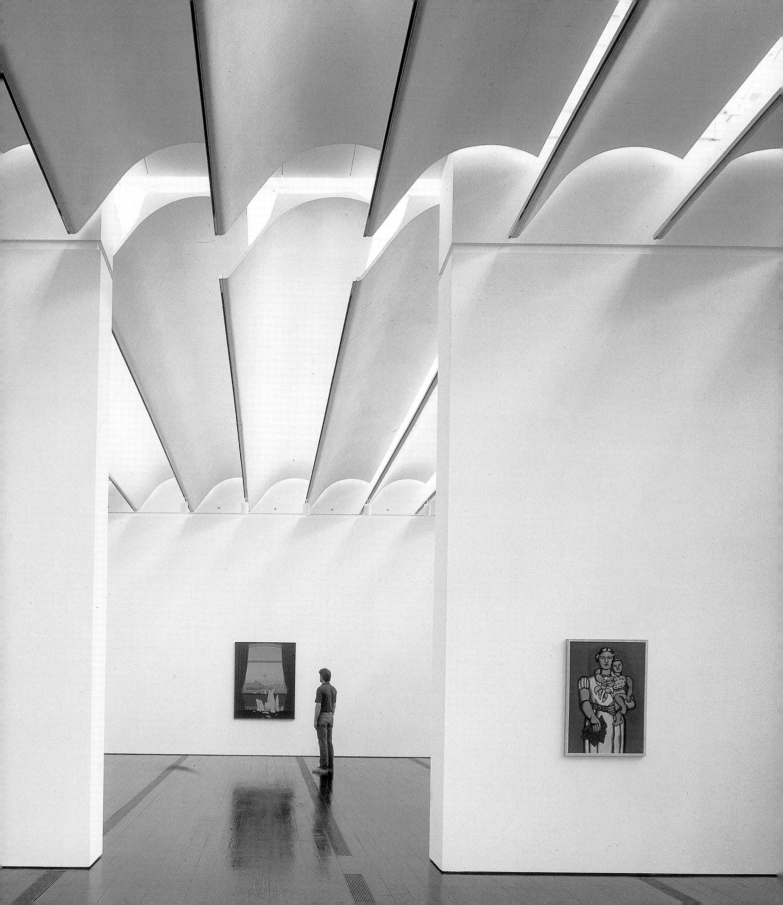

Columbus International Exposition '92

Genoa, Italy
1988-92

At the end of the 1980s, the municipality of Genoa decided to organize an international exhibition to celebrate the 500th anniversary of Christopher Columbus' discovery of America. The site selected for the event was part of the Old Port which was still operational at the time, although it was eventually retired from service and replaced by a modern harbour. This provided a great opportunity to renovate a historic district of the city and, in particular, to build new, permanent installations.

An essential consideration was that the project had to create a link between Genoa's historical centre (alongside the Old Port) and the sea. This link had not existed for centuries having been severed first by the city ramparts, then by warehouses, railways, Custom Barriers and most recently by a highway. Undertaking the project was tantamount to performing open-heart surgery on the city.

The challenge was two-fold: on the one hand, to transform wharves dating from the 17th to the 20th centuries into public spaces. On the other, to develop a strong relationship between the Port and the City. The project also afforded an opportunity to reclaim one of the largest European historic centres. (The idea had grown from a 1981 model urban renovation project for an old district in Genoa, *Molo Vecchio*.)

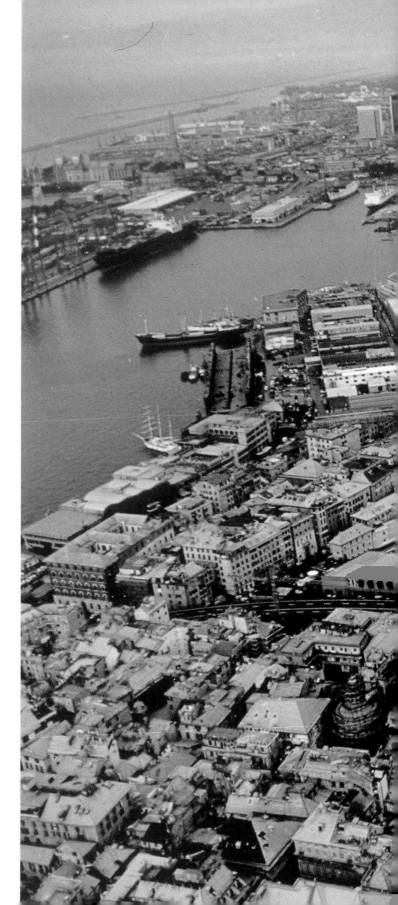

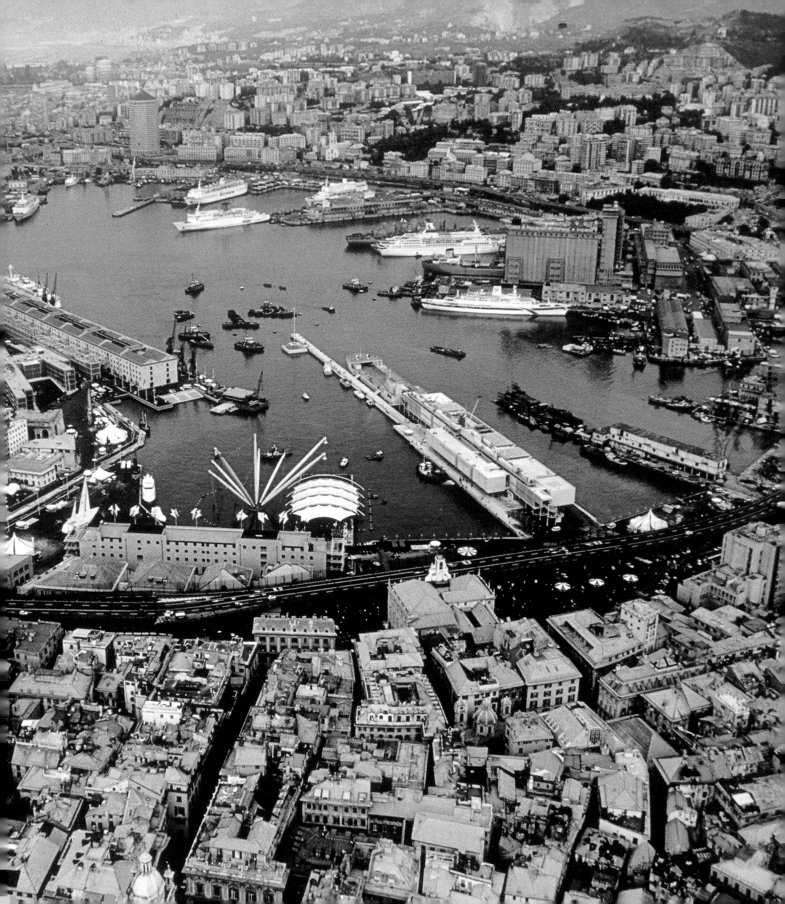

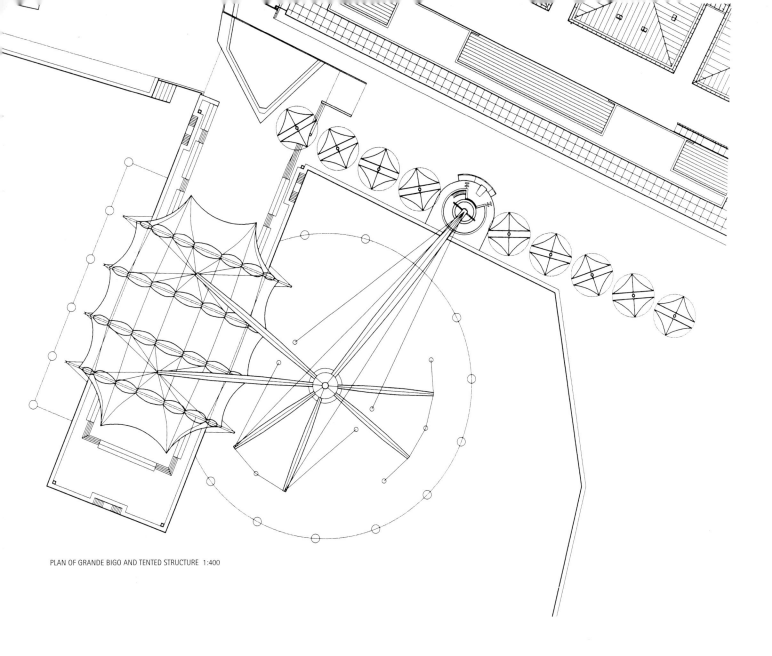

PLAN OF GRANDE BIGO AND TENTED STRUCTURE 1:400

In practical terms, the project entailed restoring the old buildings along the quayside (for instance, the three-story, 400 metre-long cotton warehouse, which would serve various functions such as a library and auditorium). However, great care was taken to ensure that these alterations did not betray the original spirit of the surrounding district. New constructions such as the aquarium and the naval derrick which symbolize the new port life were always conceived in harmony with the spirit of the old.

The Port's link to the city was achieved by extending the district's short streets to the waterfront: *Via Del Mare,* one of the main thoroughfares of the historic district was extended to the centre of the Port and then onto a breakwater alongside the aquarium. More than just the realization of a construction or renovation plan, the project was also a venture intended to reclaim something of the port's glorious past. That wager seems to have been won: this section of the city has taken on a life of its own, as the district is now visited day and night by the Genovese.

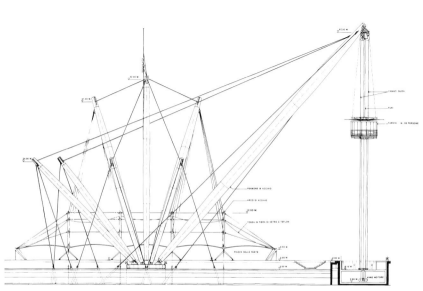

ELEVATION OF GRANDE BIGO AND TENTED STRUCTURE 1:400

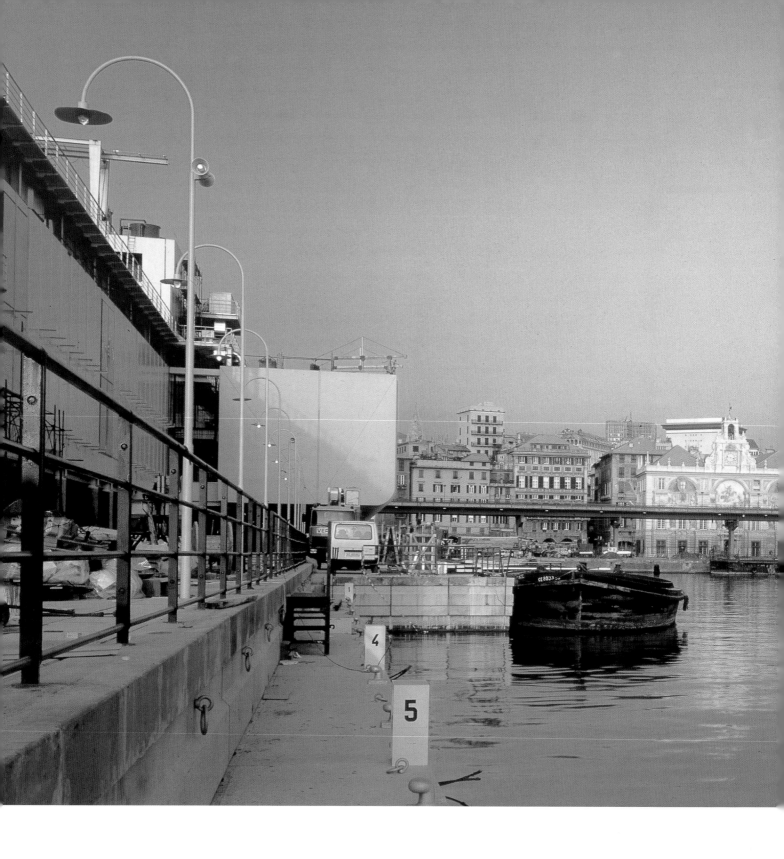

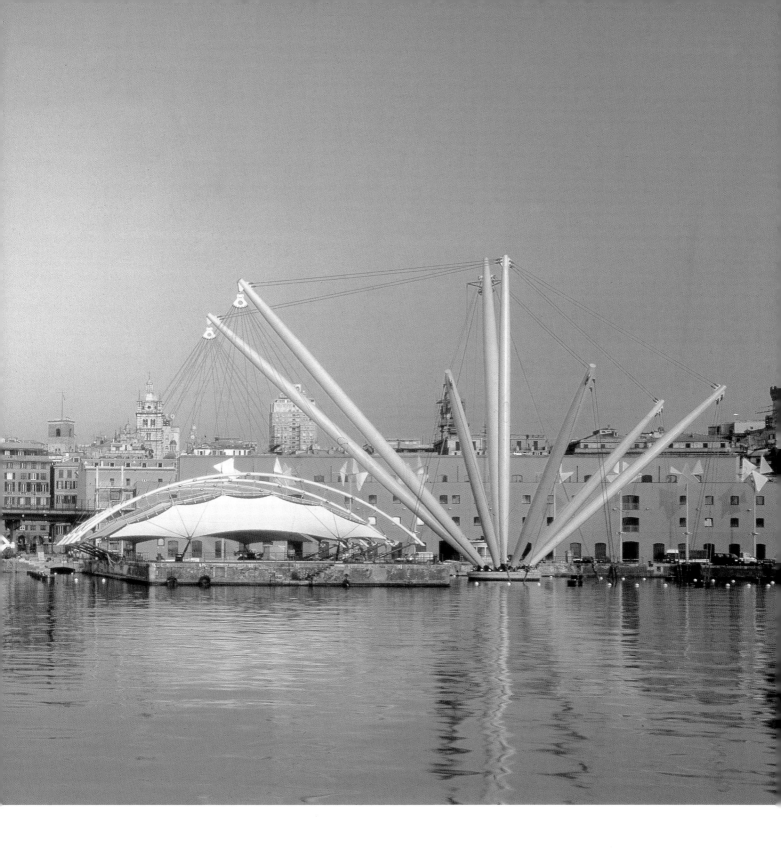

Lingotto Auditorium

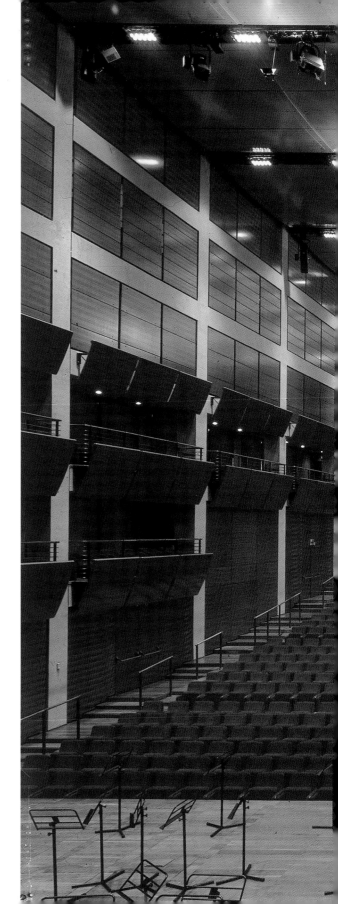

Factory Rehabilitation
Turin, Italy
1983-94

This Auditorium is one of the "surprises" that are part of the rehabilitation of Lingotto, the first great factory of Fiat in Turin which ceased production in 1982.

The large concert/conference hall has been constructed below one of the old building's four central courtyards, the floor of which has now been raised to first floor level. Here it forms a piazza between the arcades that extend the length of the main public and shopping level.

Beneath this, the bottom of the court has been excavated 14 metres down, well below the level of the old buildings foundations, to achieve the hall's requisite volume and raked floor.

For acoustic isolation, the new structure of the hall is completely independent of the old structure. The concrete frame expressed on the hall's long sides supports steel beams and concrete decking which are independent of the steel beams that support the 350 millimetre-deep concrete slab of the courtyard floor. For further sound dampening, both sets of beams are mounted on rubber pads.

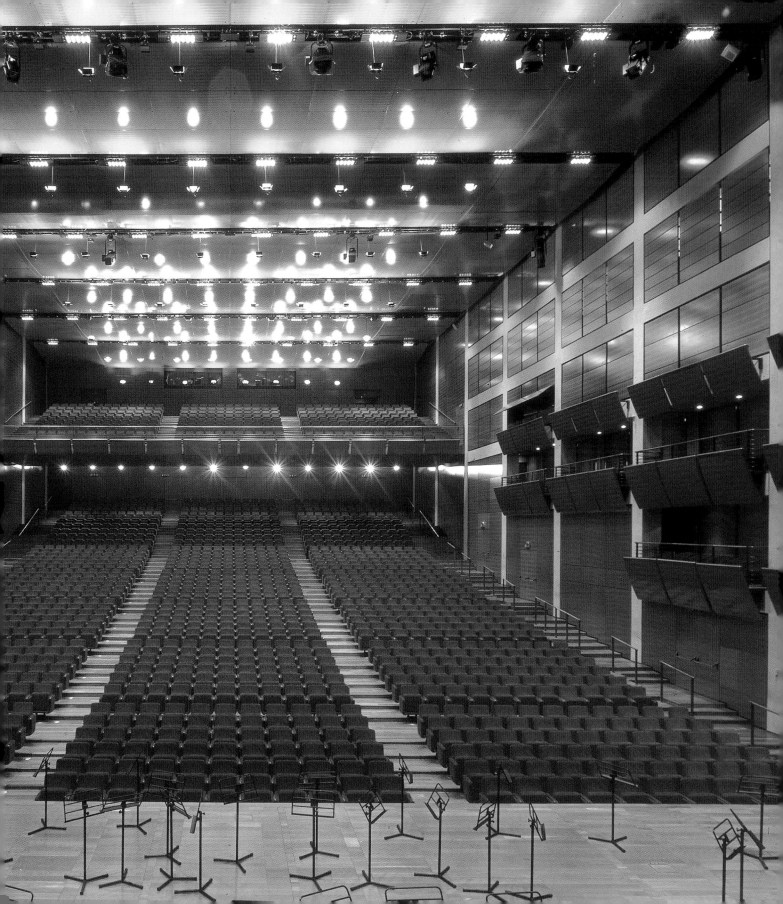

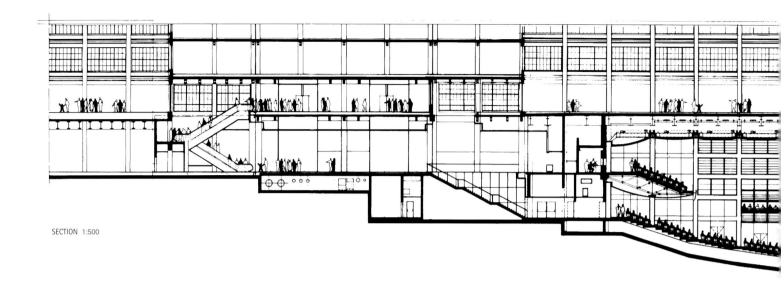

SECTION 1:500

Discounting the sloping floor, what has been created is a shoe box-shaped volume (lined on its long sides by two galleries with a row of translation booths above these), into which has been inserted a balcony at one end and a fully adjustable stage at the other. Also adjustable is the suspended ceiling of convex curved segments; each segment of the ceiling, and of the lighting grids between them, can be lowered and raised independently.

The hall is used at its maximum volume, 24,000 cubic metres, for symphony concerts when it seats 2,000 and has a reverberation time of 1.9 seconds. For conferences, when the ceiling can be lowered by as much as 6 metres decreasing the volume of the hall and adjusting the acoustics, it can have a volume of just 9,400 cubic metres and a reverberation time of less than 1.5 seconds.

The "colour" of the sound has been taken into great consideration with the use of cherry wood in the construction of the floor, the ceiling with its movable panels and the walls.

The correct Reverberation Time was obtained by drilling holes in the walls, capturing the sound with arched galleries and shattering the echo with the use of wood – which proved to be the most suitable material for this purpose.

"Sound reflectors" are hung above the orchestra which reflect the sound back to the performers so that each musician has perfect sound perception.

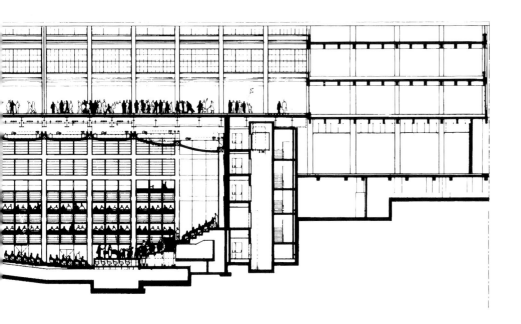

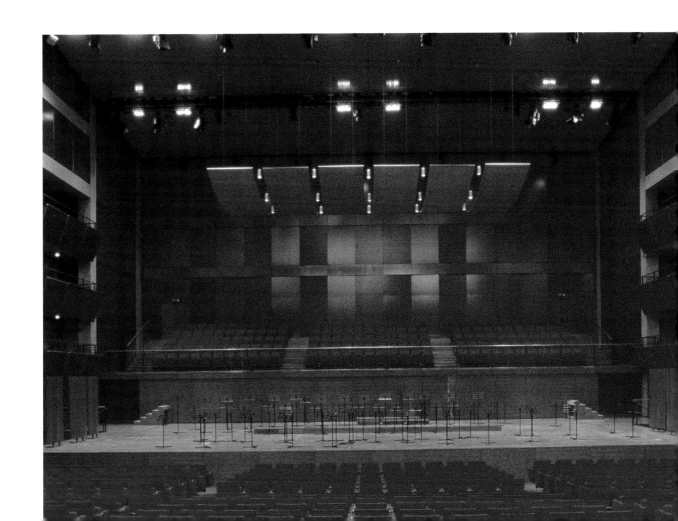

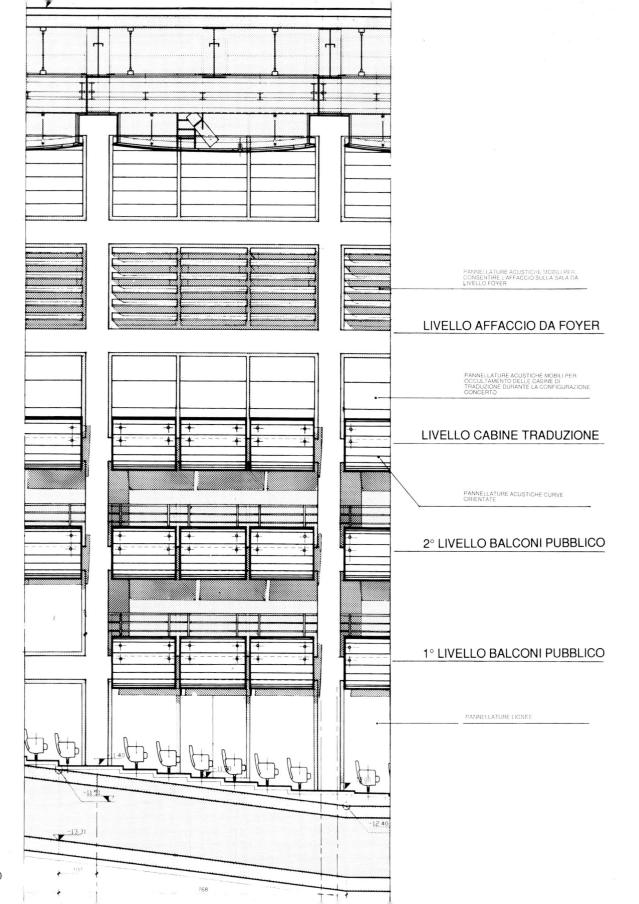

PANNELLATURE ACUSTICHE MOBILI PER
CONSENTIRE L'AFFACCIO SULLA SALA DA
LIVELLO FOYER

LIVELLO AFFACCIO DA FOYER

PANNELLATURE ACUSTICHE MOBILI PER
OCCULTAMENTO DELLE CABINE DI
TRADUZIONE DURANTE LA CONFIGURAZIONE
CONCERTO

LIVELLO CABINE TRADUZIONE

PANNELLATURE ACUSTICHE CURVE
ORIENTATE

2° LIVELLO BALCONI PUBBLICO

1° LIVELLO BALCONI PUBBLICO

PANNELLATURE LIGNEE

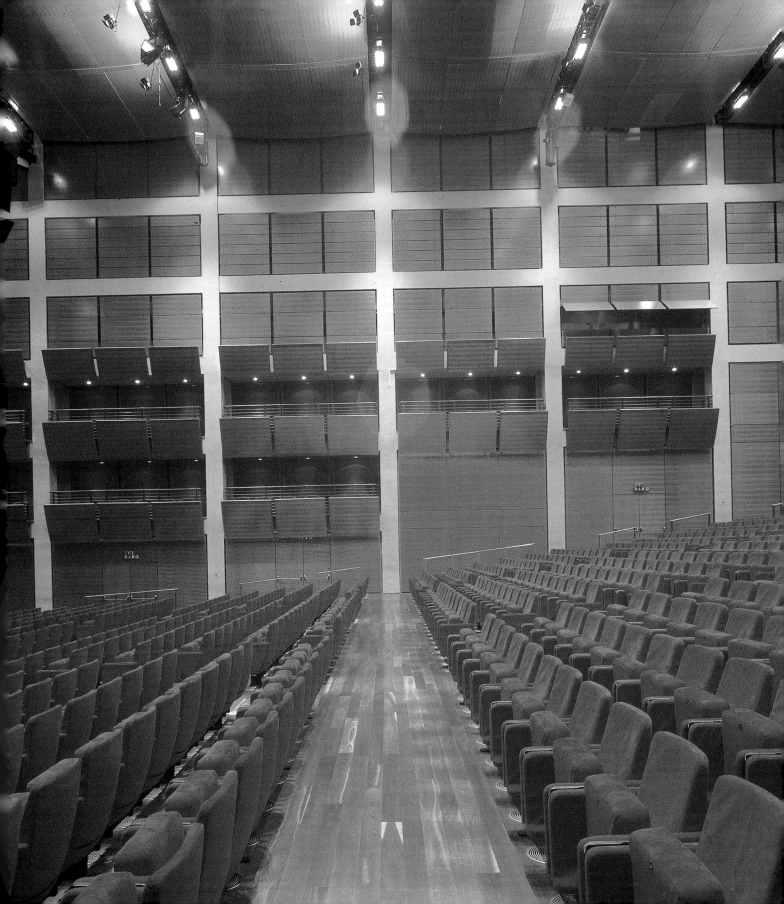

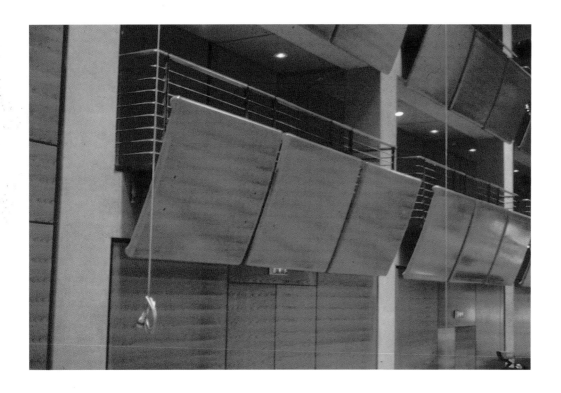

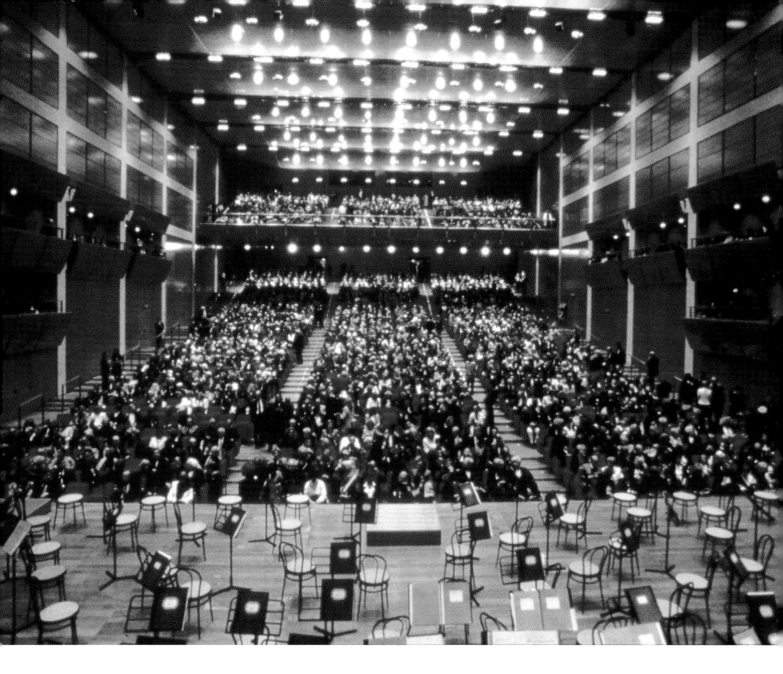

Beyeler Foundation

Museum
Riehen, Switzerland
1992-97

As was the case with the Menil Collection, the art patron and collector Ernst Beyeler wanted to build a museum to house his art collection and make it accessible to the general public. Mr. Beyeler had a very precise vision of how his project should take shape. Primarily, he wanted the museum to be totally integrated into nature by being sited amidst the trees of the once-private park in Switzerland surrounding Villa Berower, a historic monument.

The Beyeler foundation consists of four bearing walls of equal length running parallel to the wall enclosing the site; and the exhibit spaces are arranged in straight rows in relation to the resulting space. In cross-section, however, the project becomes much more dynamic with the easternmost wall gradually tapering off, guiding the visitors toward the entrance.

Mr. Beyeler had another requirement: natural light. To that end, the entire museum is covered by a transparent sloping roof and from certain vantage points the roof seems to float away from the building. It is held up by a simple metal structure which is virtually invisible from inside the exhibition spaces, lending the building an overall sense of lightness, in contrast with the rocky surfaces of the walls.

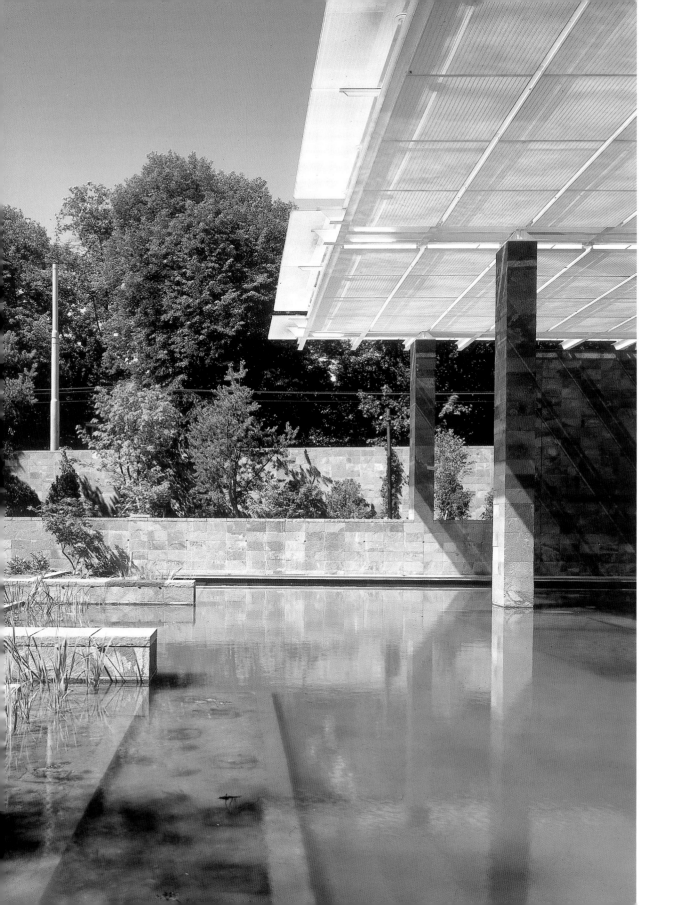

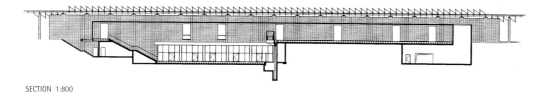

SECTION 1:800

PLAN 1:800

The walls, including the enclosing walls, are all covered with a stone which resembles the red sandstone found in the Basel area but which actually comes from Argentina. Compared to local stone, it is both more weather-resistant and requires less maintenance.

A glass partition separates the west elevation from a long, narrow garden: the park, the trees and the lake seem to enter into the museum. The interior and the exterior seem in perfect balance: a sense of calm reigns over the entire site.

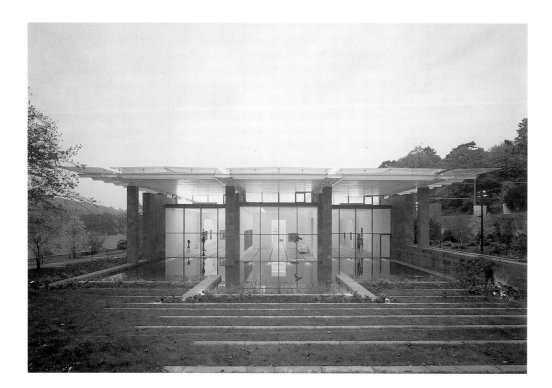

SECTION 1:1000

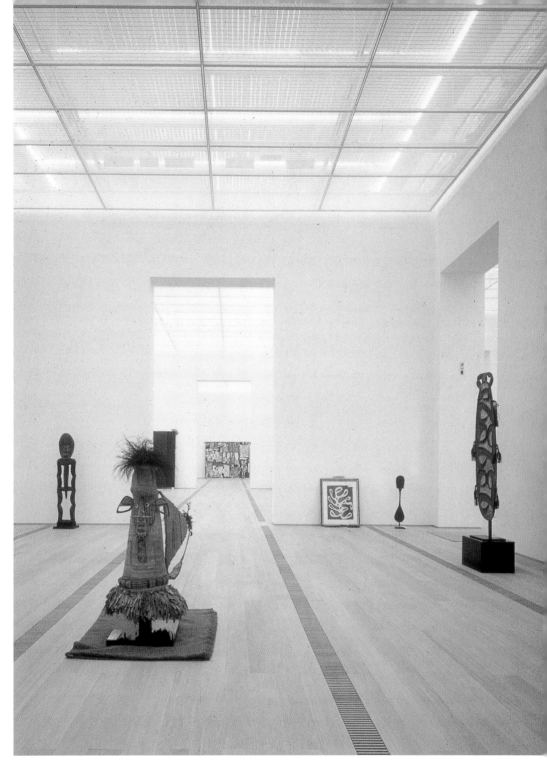

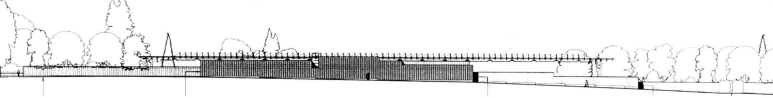

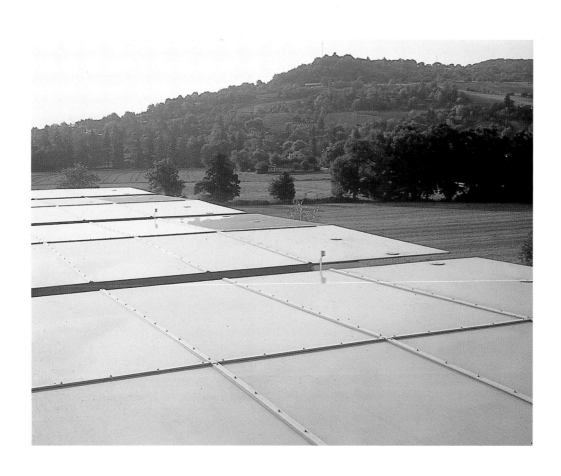

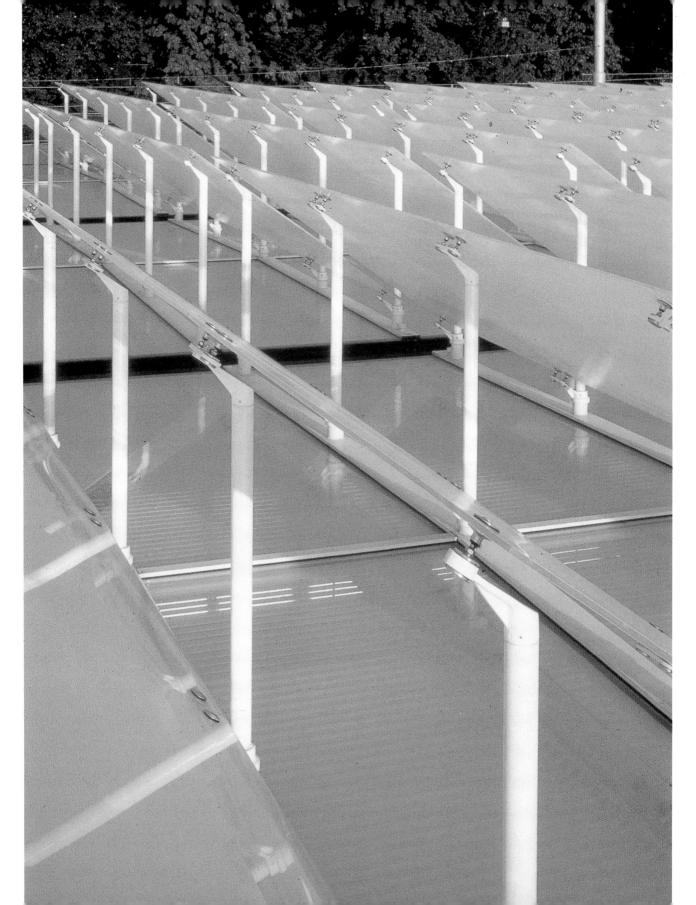

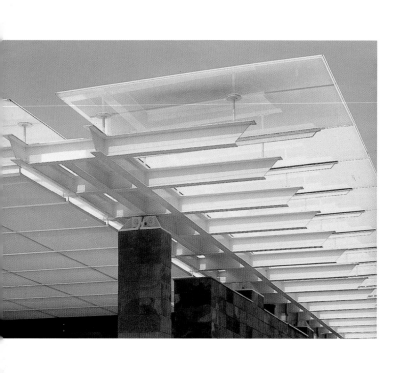

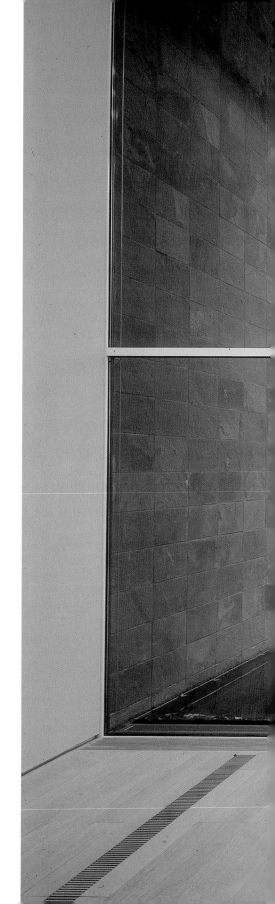

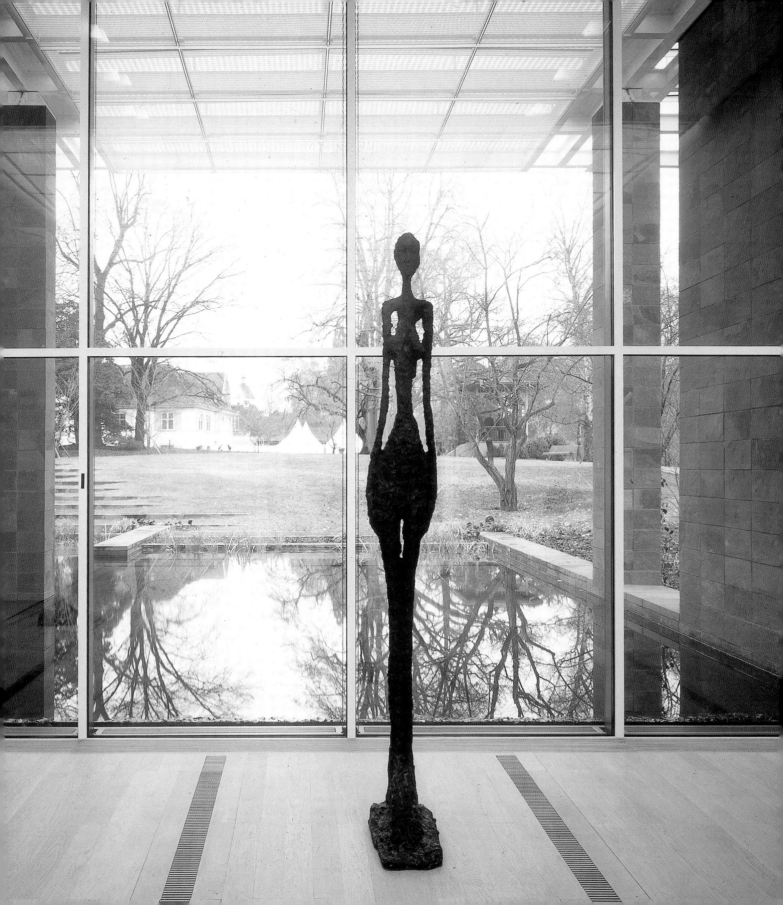

1982-86
Menil Collection
Houston, Texas U.S.A

client	Menil Foundation
architect	Piano & Fitzgerald
design team	S. Ishida (associate in charge), M. Carroll, F. Doria, M. Downs, C. Patel, B. Plattner (associate architect), C. Susstrunk
consultants	Ove Arup & Partners (P. Rice, N. Nobel, J. Thornton) (structure); Hayne & Whaley Associates (services); Galewsky & Johnston (local services); R. Jensen (fire prevention)

1983-1984
Prometeo Musical Space
Venice and Milan, Italy

client	Ente Autonomo, Teatro alla Scala, Milan
architect	Renzo Piano Building Workshop
design team	C. Abagliano, D. L. Hart, S. Ishida (associate in charge), A. Traldi, M. Visconti
consultants	M. Milan, S. Favero (structure); L. Nono (music); M. Cacciari (text); C. Abbado (director) With: R. Cecconi
contractor	G. F. Dioguardi S.p.A

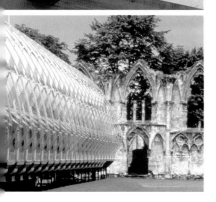

1983-86
IBM **Travelling Pavilion**

client	IBM Europe
architect	Renzo Piano/Building Workshop/Atelier de Paris
design team	O. Di Blasi, F. Doria, G. Fascioli, S. Ishida (associate in charge), J. B. Lacoudre, N.Okabe (associate architect), P. Vincent, A. Traldi
consultants	Ove Arup & Partners (P. Rice, T. Barker) (structural and mechanical engineering)
contractor	Calabrese Engineering S.p.a.

<div align="center">

1983–1994
Lingotto Auditorium Factory Rehabilitation
Turin, Italy

</div>

architect Renzo Piano Building Workshop, architects

Competition, 1983

client Fiat S.p.A.

design team S. Ishida (associate architect), C. Di Bartolo, O. Di Blasi,
M. Carroll, F. Doria, G. Fascioli, E. Frigerio, R. Gaggero, D. L. Hart,
P. Terbuchte, R. V. Truffelli

**Feasibility
Study, 1985**

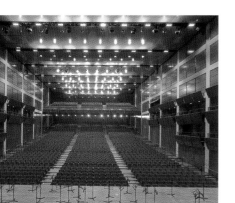

client Municipality of Turin

design team S. Ishida (associate architect), E. Frigerio, O. Di Blasi,
K. Dreissigacker, M. Mattei with G. G. Bianchi, G. Fascioli, M. Visconti

consultants G. De Rita (economics); R. Guiducci (sociology)

**Design Development and
Consruction Phase, 1991–**

client Lingotto S.r.l.

design team M. Carroll, M. Cattaneo, M. Cucinella, S. Ishida, D. Piano, B. Plattner, S. Scara-
bicchi, R. V. Truffelli, M. van der Staay, M. Varratta,
P. Vincent (senior partners, partners and architects in charge)
with P. Ackermann, A. Alborghetti, E. Baglietto (partner),
A. Belvedere, L. Berellini, A. Calafati, A. Carisetto, G. Cohen, F. Colle, P. Costa, S.
De Leo, A. De Luca, S. Durr, K. Fraser, A. Giovannoni, C. Hays, G. Hernandez, C.
Herrin, W. Kestel, P. Maggiora, D. Magnano, M. Mariani, K.A. Naderi, T. N'Guyen,
T. O'Sullivan, M. Rossato Piano, M. Pimmel, A. Sacchi, M. Salerno, P. Sanso, A.
Stadlmayer, A.H. Téménidès, N. Van Oosten, H. Yamaguchi and S. Arecco, F. Bar-
tolomeo, M. Busk-Petersen, N. Camerada, M. Carletti, I. Cuppone, R. Croce Ber-
mondi, A. Giovannoni, M. Nouvion, P. Pedrini, M. Piano; I. Corte, D. Guerrisi, G.
Langasco,
L. Siracusa (CAD Operators);
D. Cavagna, P. Furnemont (models)

consultants Ove Arup & Partners, AI Engineering,
Fiat Engineering (structure and services);
Arup Acoustics, Müller Bbm, Peutz & Associés (acoustics);
PI Greco Engineering (fire prevention);
Davis Langdon Everest, Fiat Engineering, GEC Ingénierie (cost control); Techplan
(theater equipment);
ECL (exhibition area management); CSST (commercial);
P. Castiglioni (lighting); P.L. Cerri, ECO S.p.A. (graphic design);
F. Santolini (interiors); CIA (interiors/shopping center);
Studio Vitone & Associati, F. Levi/G. Mottino (site supervision);
Studio Program (I. Castore), R. Montauti/B. Roventini/G. Vespignani/S. Rum/E.
Bindi (building inspectors)

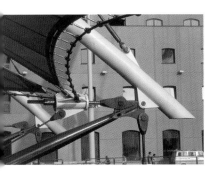

1985–92
Columbus
International Exposition '92
Genoa, Italy

client	City of Genoa
architect	Renzo Piano Building Workshop, architects
design team	S. Ishida (partner) with E. Baglietto, G. G. Bianchi, M. Carroll, O. De Nooyer, G. Grandi, D. L. Hart, C. Manfreddo, R. V. Truffelli (architects in charge), P. Bodega, V. Tolu and A. Arancio, M. Cucinella, G. Fascioli, E. L. Hegerl, M. Mallamaci, G. Mc Mahon, M. Michelotti, A. Pierandrei, F. Pierandrei, S. Smith, R. Venelli, L. Vercelli; S. D'Atri, S. De Leo, G. Langasco, P. Persia (CAD Operators)
consultants	Ove Arup & Partners, L. Mascia/D. Mascia, P. Costa, L. Lembo, V. Nascimbene, A. Ballerini, G. Malcangi, Sidercard, M. Testone, G. F. Visconti (structure); Manens Intertecnica(services); M. Semino (supervisor for urban area and historic buildings); Cambridge Seven Associates (P. Chermayeff) (aquarium consultant); F. Doria, M. Giacomelli, S. Lanzon, B. Merello, M. Nouvion, G. Robotti, A. Savioli (technical consultants); STED (cost control); D. Commins (acoustics for congress hall); P. Castiglioni (lighting); E. Piras (site supervision for special aquarium equipment); L. Moni (site supervision); Scène (scenography); Cetena (naval engineer); G. Macchi (Italian Pavilion exhibition curator); Origoni/Steiner (graphic design)
contractor and management	Italimpianti

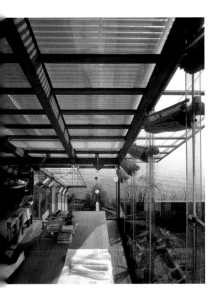

1989–94
Renzo Piano
Building Workshop
Punta Nave, Genoa, Italy

client	Renzo Piano Building Workshop
architect	Renzo Piano Building Workshop
design team	M. Cattaneo (architeet in charge), S. Ishida (partner), M. Lusetti, F. Marano, M. Nouvion with M. Carroll, O. Di Blasi, R. V. Truffelli, M. Varratta and D. Cavagna (models)
consultants	A. Bellini, L. Gattoronchieri (soil engineers); P. Costa (structure); M. Desvigne (landscaping); C. Di Bartolo (bionic research)

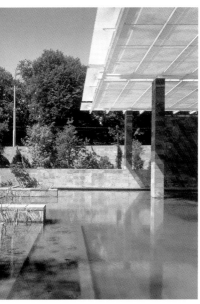

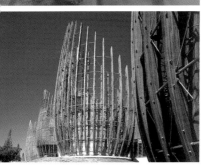

1991–97
Beyeler Foundation Museum
Riehen (Basel), Switzerland

client	Beyeler Foundation
architect	Renzo Piano Building Workshop
	B. Plattner, senior partner in charge
	in association with Burckhardt + Partner AG, Basel

Preliminary Design, 1992

design team	L. Couton (architect in charge) with J. Berger, E. Belik,
	W. Vassaland A. Schultz, P. Darmer (models)
consultants	Ove Arup & Partners (structure and services.)

Construction Phase 1993-1997

design team	L. Couton (architect in charge) with P. Hendier, W. Matthews,
	R. Self and L. Epprecht; J. P. Allain (models)
consultants	Ove Arup & Partners, C. Burger + Partner AG (structure); Bogenschütz AG (plumbing); J. Forrer AG (HVAC); Elektrizitäts AG (electrical engineering); J. Wiede, Schönholzer+ Stauffer (landscaping)

1991–98
Tjibaou Cultural Centre
Nouméa, New Caledonia

client	Agence pour le Développement de la Culture
architect	Renzo Piano Building Workshop
	P. Vincent, senior partner in charge

Competition, 1991

design team	A. Chaaya (architect in charge) with F. Pagliani,
	J. Moolhuijzen, W. Vassal and O. Doizy, A. Schultz (models)
consultants	A. Bensa (ethnologist); Desvigne & Dalnoky (landscaping); Ove Arup & Partners (structure and ventilation); GEC Ingénierie (cost control), Peutz & Associés (acoustics), Scène (scenography)

Preliminary design, 1992

design team	A. Chaaya, D. Rat (architects in charge) with J. B. Mothes, A. H. Téménidès and R. Phelan, C. Catino, A. Gallissian, R. Baumgarten; P. Darmer (models)
consultants	A. Bensa (ethnologist); GEC Ingénierie (cost control); Ove Arup & Partners (structural & MEP engineering concept); CSTB (environmental studies); Agibat MTI (structure); Scène (scenography); Peutz & Associés (acoustics); Qualiconsult (security); Végétude (planting)

Design Development and Construction phase, 1993-1998

design team	D. Rat, W. Vassal (architects in charge) with A. El Jerari, A. Gallissian, M. Henry, C. Jackman, P. Keyser, D. Mirallie, G. Modolo, J. B. Mothes, M. Pimmel, S. Purnama, A. H. Téménidès and J.P. Allain (models)
consultants	A. Bensa (ethnologist); Agibat MTI (structure); GEC Ingénierie (MEP engineering and cost control); CSTB (environmental studies); Scène (scenography); Peutz & Associés (acoustics); Qualiconsult (security); Végétude (planting); Intégral R. Baur (signing)

Completed Projects

1964	Lightweight Structures
1973	Office building for B&B, Como, Italy
1974	One-family homes, Cusago, Milan, Italy
1977	Centre Georges Pompidou, Paris, France (with Richard Rogers)
	IRCAM, Institute for acoustic research, Paris, France
1979	Participation project for the rehabilitation of historical centres, Otranto, Italy
1980	VSS Experimental vehicle for FIAT, Turin, Italy
1982	Housing in Rigo district, Perugia, Italy
	A. Calder retrospective exhibition, Turin, Italy
1984	Schlumberger factories rehabilitation, Paris, France
	Musical space for Prometeo opera by L. Nono, Venice, Italy
	Office building for Olivetti, Naples, Italy
1985	Office building for Lowara factory, Vicenza, Italy
1986	IBM Travelling Exhibition in Europe
	Museum for the Menil Collection, Houston, U.S.A.
1987	Headquarter for Light Metals Experimental Institute, Novara, Italy
1990	S.Nicola Football stadium, Bari, Italy
	Bercy commercial centre, Paris, France
	IRCAM Extension, Paris, France
	Cruise ships for P&O, U.S.A.
1991	Housing for the City of Paris, Rue de Meaux, Paris, France
	Thomson factories, Guyancourt, France
	Underground stations for Ansaldo, Genoa, Italy
1992	Headquarter for the Credito Industriale Sardo, Cagliari, Italy
	Columbus International Exposition; Aquarium and Congress Hall, 1992, Genoa, Italy
1994	Lingotto Congress-Concert Hall, Turin, Italy
	Kansai International Airport, Osaka, Japan
	Renzo Piano Building Workshop Office, Genoa, Italy
1995	Cy Twombly Pavilion, Houston, U.S.A.
	Meridien Hotel at Lingotto and Business Centre, Turin, Italy
	Headquarter Harbour Authorities, Genoa, Italy
1996	Cinema, Offices, Contemporary Art Museum, Congress Centre (200, 800 and 300 seats), Landscape, Cité Internationale, Lyon, France
	I Portici (Shopping Street at Lingotto), Turin, Italy
1997	Ushibuka Bridge, Kumamoto, Japan
	Reconstruction of the Atelier Brancusi, Paris, France
	Museum of Science and Technology, Amsterdam, The Netherlands
	Museum of the Beyeler Foundation, Riehen, Basel, Switzerland
	The Debis building Headquarters, Daimler Benz, Potsdamer Platz, Berlin, Germany
	Wind tunnel for Ferrari, Maranello, Modena, Italy

1998	Cultural Center Jean Marie Tjibaou, Nouméa, New Caledonia
	Mercedes Benz Design Centre, Stuttgart, Germany
	Daimler Benz Potsdamer Platz projects: musical theatre, Imax
	theatre, residentials, retails, Berlin, Germany
	Lodi Bank Headquarters, Lodi, Italy
1999	Hotel and Casino, Cité Internationale, Lyon, France
	Completion open spaces, Old Harbour, Genoa, Italy
	Commercial and offices centre, Lecco, Italy
2000	Interior and Exterior Rehabilitation of the Pompidou Centre, Paris, France
	Daimler Benz, Potsdamer Platz, offices, Berlin, Germany

Projects in Progress

1991	Padre Pio Pilgrimage Church, San Giovanni Rotondo, Foggia, Italy
1994	Auditorium Rome, Italy
1995	Commercial leisure and service centre, Nola, Napoli, Italy
1996	Contemporary Art Museum, Varnamö, Sweden
	High-Rise office block, Sydney, Australia
1997	KPN Telecom office tower, Rotterdam, The Netherlands
	Auditorium Parma, Italy
	Harvard University Art Museum Master Plan, Renovation and
	Expansion Project, Harvard, Cambridge, Massachusetts, U.S.A.
1998	Headquarters of the newspaper "Il Sole 24 Ore", Milan, Italy
	Cloister of the Capuchin Monks, San Giovanni Rotondo, Foggia, Italy
	Hermes Tower, Tokyo, Japan
	New subway stations in Genoa, Italy
	Lingotto Phase 3 (university, cinema, retail), Turin, Italy
1999	Paul Klee Museum, Bern, Switzerland
	Extension Art Institute of Chicago, Chicago, U.S.A.
	Extension Beyeler Museum, Riehen, Switzerland
	Department store, Cologne, Germany
	The Nasher Sculpture Centre, Dallas, U.S.A.
	Extension Woodruff Arts Centre, Atlanta, U.S.A.
	Braco de Prata, housing complex, Lisbon, Portugal
2000	Extension California Academy of Sciences, San Francisco, U.S.A
	New headquarters Virgin Continental Europe, Paris France

Prizes and Acknowledgements	1978	Union Internationale des Architects Honorary Fellowship, Mexico City, Mexico
	1981	Compasso d'Oro Award, Milan, Italy
		AIA Honorary Fellowship, U.S.A.
	1984	Commandeur des Arts et des Lettres Award, Paris, France
	1985	Legion d'Honneur Paris, France
		R.I.B.A. Honorary Fellowship in London, England
	1989	R.I.B.A. Royal Gold Medal for Architecture, England
		Cavaliere di Gran Croce award by the Italian Government, Rome, Italy
	1990	Honorary Doctorship, Stuttgart University, Germany
		Kyoto Prize, Inamori Foundation, Kyoto, Japan
	1991	Neutra Prize, Pomona, California, U.S.A
	1992	Honorary Doctorship, Delft University, The Netherlands
	1994	American Academy of Arts and Letters Honorary Fellowship, U.S.A
		Arnold W. Brunner Memorial Prize, U.S.A
		Officier, l´Ordre National du Mérite, Paris, France
		Goodwill Ambassador of Unesco for Architecture
		Premio Michelangelo in Rome, Italy
		Prize for Actuactiones temporales de Urbanismo y Arquitectura from the Ayuntamiento de Madrid, Spain
	1995	Art Prize of the Akademie der Künste, Berlin, Germany
		Praemium Imperiale, Tokyo, Japan
		Erasmus Prize, Amsterdam, The Netherlands
	1996	Premio Capo Circeo, Rome, Italy
		Telecom Prize, Naples, Italy
	1997	Diploma European Award for Steel Structures for the Elevated Heliport Structure at Lingotto, Torino, Italy
	1998	The Pritzker Architecture Prize, The White House, Washington, U.S.A.
	1999	Architect of the Nationale Academy of San Luca, Rome, Italy
	2000	Chevalier, Ordre National de la Légion d'Honneur, Paris, France
		Leone d'Oro to the career, Venice, Italy